IMAGES
of England

YARDLEY

IMAGES
of England

YARDLEY

Compiled by
Michael Byrne

TEMPUS

First published 1995, reprinted 1999
Copyright © Michael Byrne, 1995

Tempus Publishing Limited
The Mill, Brimscombe Port,
Stroud, Gloucestershire, GL5 2QG

ISBN 0 7524 0339 7

Typesetting and origination by
Tempus Publishing Limited
Printed in Great Britain by
Midway Clark Printing, Wiltshire

Contents

Acknowledgements

I would like to thank Martin Flynn for encouraging me to compile this book, and for his work with local researchers in Yardley and Hay Mills. Several individuals have been very helpful to me, notably Sheila Fowler, John Painter, Robert Ryland, Chris Upton, Eileen Geen, and Brian Mathews.

I would like to thank Birmingham Library Services Central and South Yardley libraries and the East Bermingeham Historical Group for letting me use their collections of photographs. Particular individuals and groups who have lent photographs are:

St. Edburgha's Parochial Church Council for the Canon Cochrane Collection: pages 12, 30 upper, 31 lower, 35, 67 lower, 104 upper, John Painter: pages 53, 54 upper, 74-79, 83 lower, 109, 110 upper, 122-125, Colin Giles: pages 38 upper, 48 upper, 52 lower, 58, 60 upper, 67 upper, Gill Tait for the Thomas Capel Smith photographs: pages 41, 83 upper, 84-86, Valerie Blick: pages 57 lower, 59 upper, 95 lower, 120, Annie Taylor: page 121.

If there is anyone who I have failed to acknowledge, I apologise here and now.

Introduction

The name Yardley used to refer to a much bigger entity than it does now, namely the old Parish from Yardley Wood to Lea Village, seven and a half miles long and eleven and a half square miles in area. Purists today might argue that the Village proper is the only part worthy of the name, while Yardley is also the name of a Municipal Ward and a Parliamentary Constituency. For the purpose of this book it is envisaged as an area from the River Cole and Hay Mills to the Sheldon border from west to east, and from south Stechford to South Yardley from north to south. Most Yardleians would have lived, worked, shopped or walked here. Most of the urbanization of Yardley took place between the Wars, so many rural memories linger in people's minds, but there was also industrial development and a strong village identity at Hay Mills. People also have good memories of the estates built in the inter-war years, and of the life they lived then. Nearly all the photographs in this book cover the period from about 1870 to 1940.

The first known reference to Yardley is in King Edgar's Charter of 972, which confirmed Gyrdleahe as a possession of Pershore Abbey. However the Parish Church dedicated to King Alfred's granddaughter Edburgha was not established by the Abbey, but by Aston Church in Lichfield Diocese. The present church was begun in the thirteenth century near the manor house, with a fifteenth century tower and spire. Those who held the manor rarely lived there, and the manor house site was unoccupied after 1700. Yardley was a Crown possession for well over one hundred years. In 1629 it was bought by Sir Richard Grevis of Moseley Hall, but his heirs sold it to pay off debts in 1759. Around 1766 the lordship was bought by John Taylor, wealthy manufacturer and co-founder of Lloyds Bank. By then most of the land in the northern half of the Parish was in other hands, and his own lands were mainly around Hall Green.

Next to the church is the Trust School. The front is sixteenth century, as is the timber section on the north side: the rest is later brick, with repairs into this century. The church, the School, Blakesley Hall to the west, and Hay Hall (15th -16th century and later) are the earliest buildings surviving. Blakesley Hall is a yeoman's farmhouse of 1598, now a museum. Traces of the past survive elsewhere, sometimes only as names. For example, the undulations, or ridge and furrow, created by medieval farming methods can be seen in the park near the church. There was a water mill near the Cole where Millhouse Road is now. Generations of farmers and other rural trades in Yardley laboured on through the centuries, removing the woodland and creating the familiar patchwork appearance of the English countryside. Rural crafts like tile- and brick-making grew up, and many ponds appeared where clay had been dug out and spread on the fields.

The Coventry Road received a new alignment when the steep holloway of Redhill was abandoned early in the nineteenth century. Improved transport for coal inward, and bricks and tiles outward, came with the Birmingham and Warwick Canal of the 1790's. Yardley Wharf was at the bend of the canal where the cemetery is today: passenger flyboats to town, drawn by horses, were also available from there. Stechford acquired a station on the London to Birmingham line in 1844, and Acocks Green on the Oxford line in 1852. Yardley was in between the stations so did not become a railway suburb. Instead mansions, some with large grounds laid out like parks, appeared around the Village, and carriages were used by the owners to get to the stations. In the last decades of the century villas and terraces spread along the Coventry Road and along some of the lanes, and industry developed at Hay Mills.

From 1897 horse-buses were followed by steam-trams as far as Hay Mills. After the replacement of the river Cole bridge in 1903, electric trams ran to the Swan from 1904. Yardley Rural District Council, formed in 1895, lost its battle to keep Yardley out of Birmingham in 1911, and those who had left the City now found themselves back in it. The scene was set for a major transformation and a massive increase in population. Huge council estates and swathes of private housing covered most of the area. More industry came to Hay Mills, including famous names like Bakelite and Wilmot Breeden. Electric trams came to Stuarts Road in 1928 via a new road, Bordesley Green East. Trolleybuses then replaced trams, and motorbuses served new routes, eventually ousting the trolleybuses as well. Cinemas and a few pubs have come and gone, and even a heliport for flights to Elmdon and London made a brief appearance from 1951-2 on Heybarnes Recreation Ground just over the river. The 1965-7 underpass works at the Swan cut South Yardley in two, and the new pub has now gone as well, removing the famous focal point. In 1984-5 half of the Coventry Road at Hay Mills was swept away in more road-widening. However in 1969 Yardley Village had become the City's first Conservation Area. It was pedestrianised and upgraded to Outstanding in 1976. When you consider that widening and straightening of the road through the Village were considered in the post-1918 Town Planning Scheme, its survival is fortunate indeed. Walking into there is like entering another vanished world.

It was the 1984 roadworks in Hay Mills which prompted local researchers to try to capture the history of the area in photographs and memories. Out of their work has developed the East Bermingeham Historical Group of today. Many of the photographs they collected in their work on Hay Mills and Yardley are featured in this book. Many others come from the Central and South Yardley libraries. A few private individuals have kindly lent material, and Canon Cochrane's photographs of Yardley, recently deposited at the Central Library, also feature. Anyone who has old photographs of the area and would like to see them more widely accessible is very welcome to approach the Local Studies and History section of the Central Library.

One
Rural Views

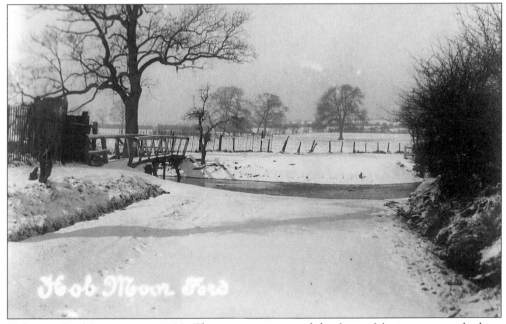

Hobmoor Ford in winter, c. 1920. The eye never tires of this beautiful winter scene, looking east.

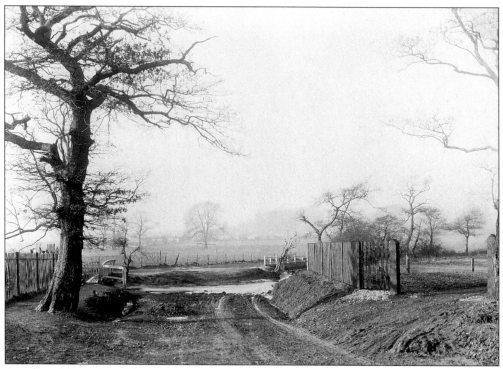

Another winter view of the ford, taken 3 December 1925.

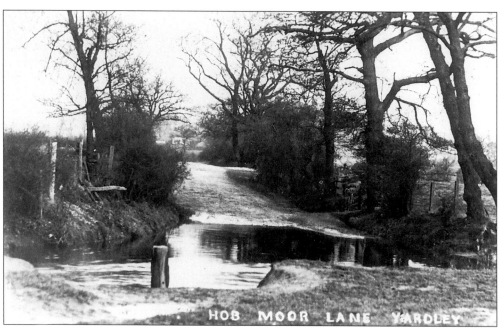

Looking up towards Fast Pits, c. 1915. Deakin's Farm was at the end of this lane.

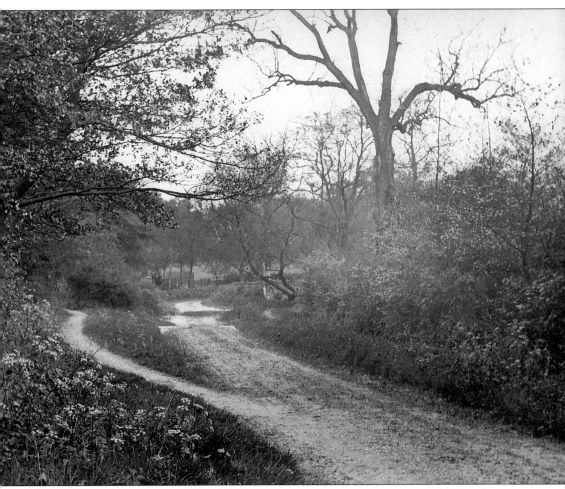

Hobmoor Ford in summer, 1918. The ford was a favourite haunt of the painter F. H. Henshaw, and the lane has been described thus: '..deep between high hedgerows. Delightful from the beginning, it reached its perfection at the point where it met the River Cole'.

Hobmoor Lane in 1913, taken by Canon Cochrane, Vicar of Yardley.

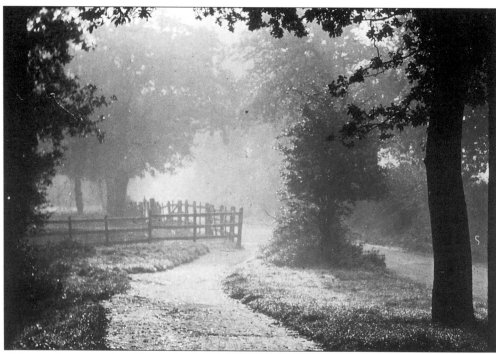

Hobmoor Lane, another Canon Cochrane picture. Clearly the lane lived up to its description.

12

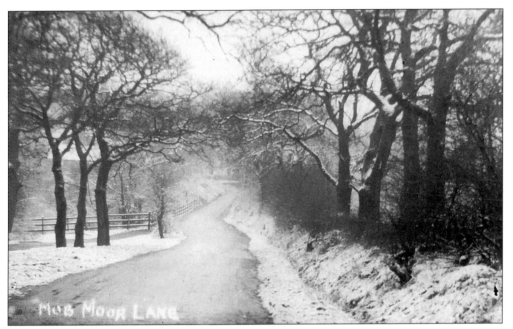

Hobmoor Lane in winter, c. 1910.

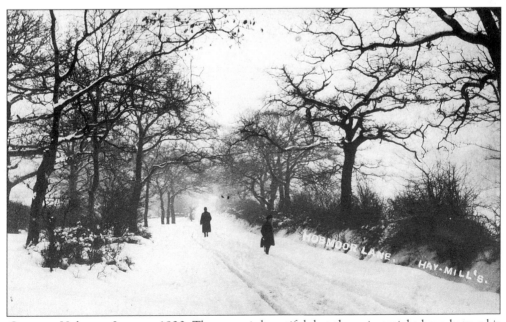

Snow on Hobmoor Lane, c. 1920. The scene is beautiful, but the going might have been a bit tricky for these men, as the lane was muddy underfoot in wet weather.

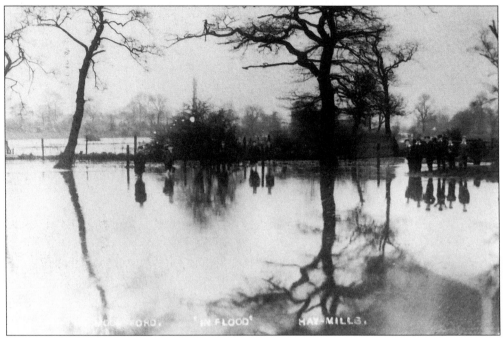

Hobmoor Ford in flood. This may have been taken in 1902, one of the years the river flooded the Coventry Road.

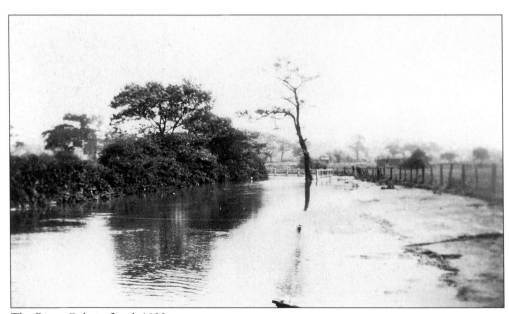

The River Cole in flood, 1922.

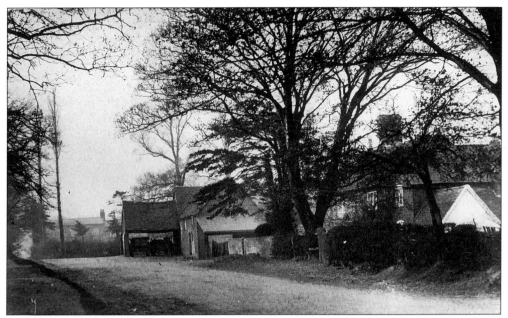

Deakin's Farm, c. 1900. Otherwise known as Fast Pits Farm, Deakin's Farm was at the junction of Holder Road, Wash Lane and today's Fast Pits Road.

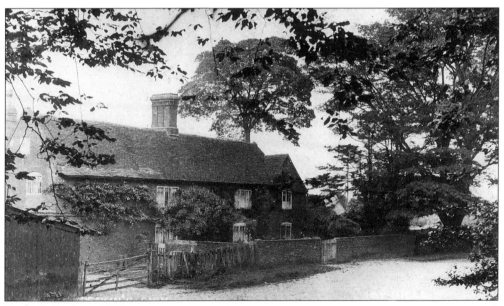

Deakin's Farm, c. 1918.

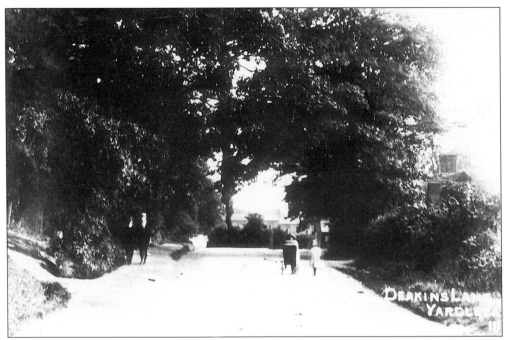

Deakins Lane, c. 1905.

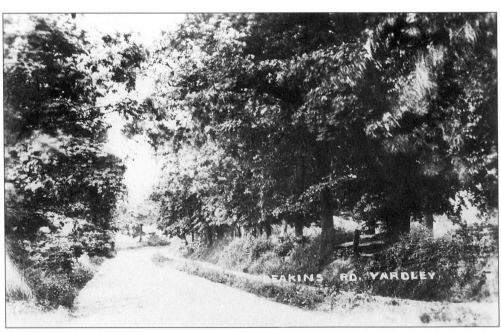

Deakins Road, c. 1910. Terraces have spread two thirds of the way along the lane by now. See page 45.

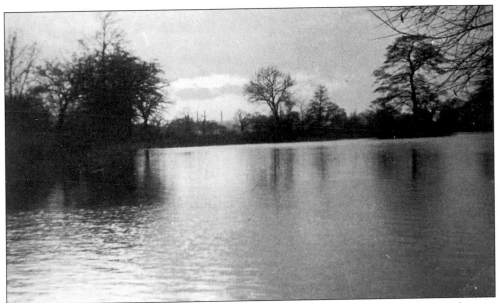

Wash Mill pool, c. 1885. The pool was drained after World War One when the council estate was built, but was not filled in until 1957, when rubble from bombed-out houses was tipped in there.

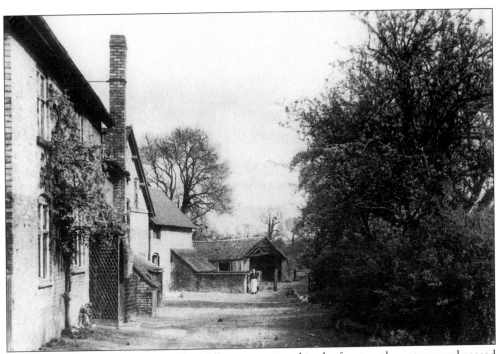

Buildings at Wash Mill, c. 1920. The Mill was mentioned in the fourteenth century, and ceased operations early this century. It stood at Millhouse Road south of Bierton Road.

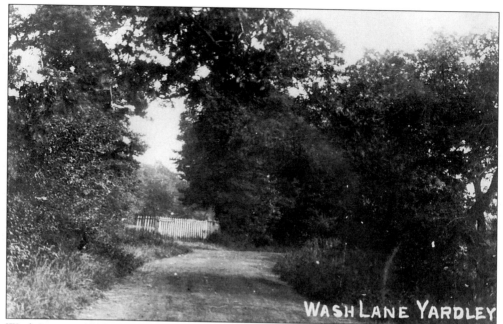

Wash Lane, c. 1910. It ran to Flavells Lane before the houses were built, and was then extended to the junction of today's Fast Pits and Holder Roads.

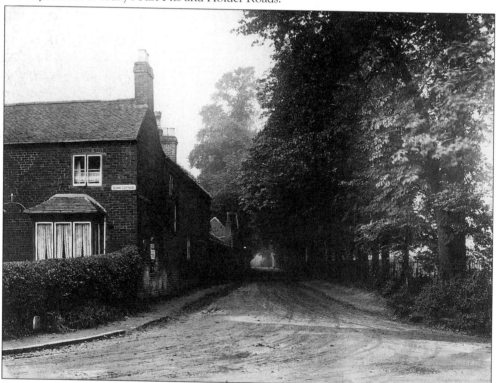

Scone Cottage and Flavells Lane at the Yew Tree junction, 10 September 1924. This first stretch of Flavells Lane is now Hobmoor Road. Mrs. E. M. Mills, nurseryman according to the directory, lived here then.

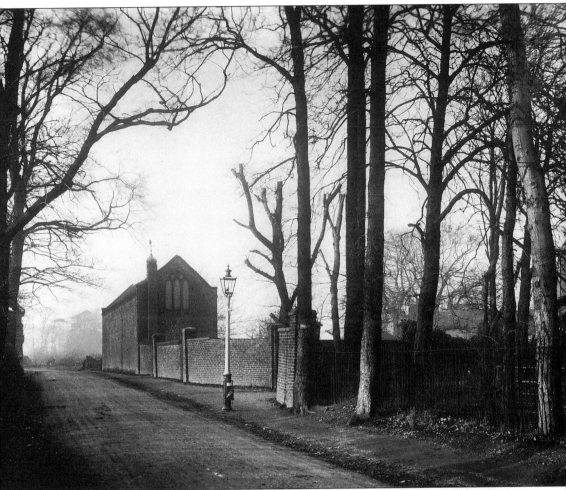

The old barn belonging to Yardley House, 2 December 1925. This photograph was taken from the east. Flavells Lane used to curve right and left to its present stretch, in open country, where it met the end of Wash Lane. Yardley House was owned by the Flavell family, but was let out to tenants. The Misses Bosworth, six of them at least, lived there together for twenty years after 1910. The Flavells sold the house and grounds to Mitchells and Butlers in 1919, who built the Yew Tree pub in the grounds in 1925. Hobmoor Road was cut west across fields after here to a new bridge of 1926, ignoring the old Hobmoor Lane, which became Fast Pits Road a little further south.

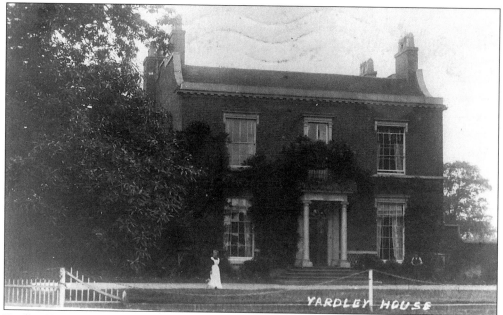

Yardley House, c. 1910. The estate was put up for sale in 1930 and the house was demolished. It stood in front of where Hobmoor Primary School is now.

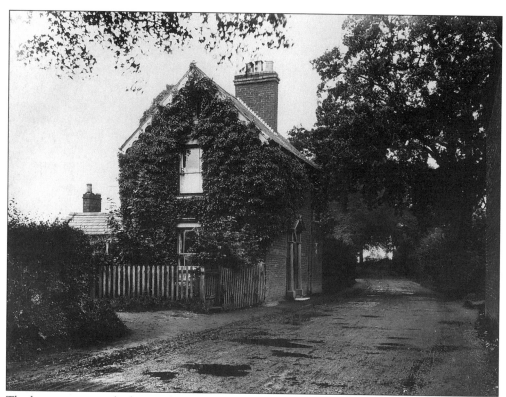

The house opposite the barn, taken 10 September 1924.

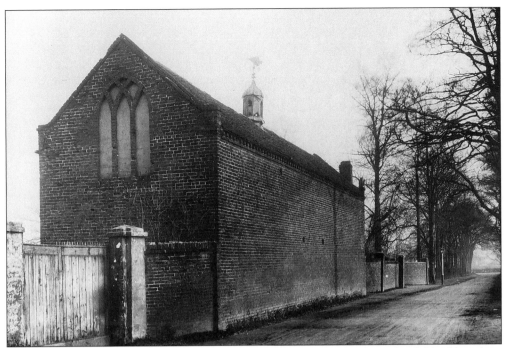

The barn from the west, 2 December 1925. This appears to be a rather splendid building for a barn, with its chimney, weathervane and windows like this. It looks as if it may have been built as a chapel: to add to the mystery, bones and pieces of stone were dug out of a garden near this site a few years ago.

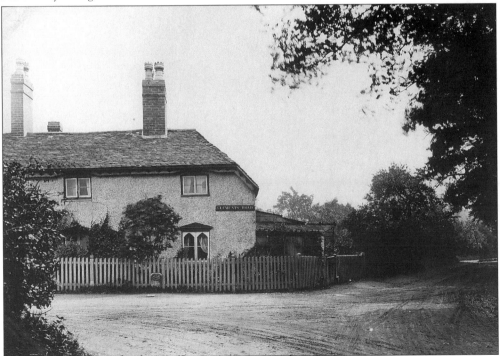

Clements Road and 'Swiss Cottages', 10 September 1924, at the junction with Flavells Lane.

Clements Road, c. 1920.

Flavells Lane and the Yardley Ex-Servicemen's Football Club's ground. The board says they were in the 1st Division, Birmingham Alliance.

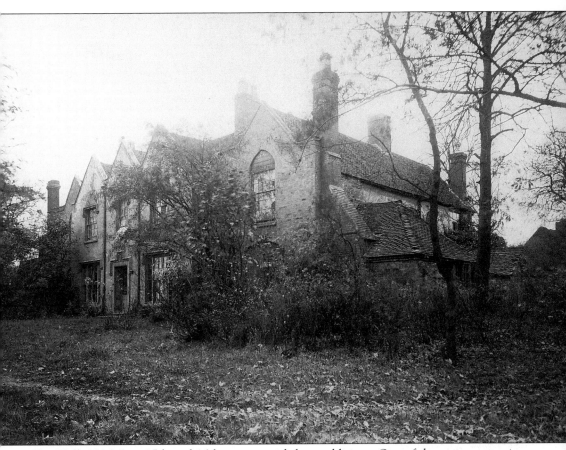

Hay Hall, 1916. It is 15th and 16th century with later additions. One of the greatest surprises locally is that Hay Hall was not demolished. The estate was bought by a Mr. Deykin and rented out to a series of farmers. The canal, then the railway, bought pieces. The Patent Butted Tube Company bought the Hall and the land around it in 1917. The house was thrown in as being of no value. Amazingly, they kept the Hall, and T.I. Reynolds restored it with the help of the City Museum between 1982 and 1984. For a number of years it was possible to go and visit the building. This Georgian façade is now the front of the building, facing north-west. The north-east wing is shown in the upper photograph overleaf and the lower photograph shows the original frontage, now the rear. The two-storeyed timber porch to the right of the corrugated roof incorporates the original main entrance to the hall. In 1948 a two-storeyed extension was built where the corrugated roof then stood.

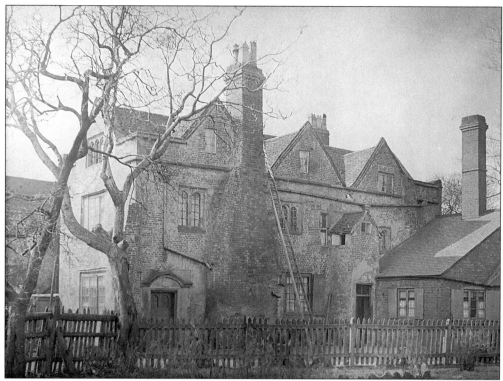

The north-east wing of Hay Hall, c. 1935.

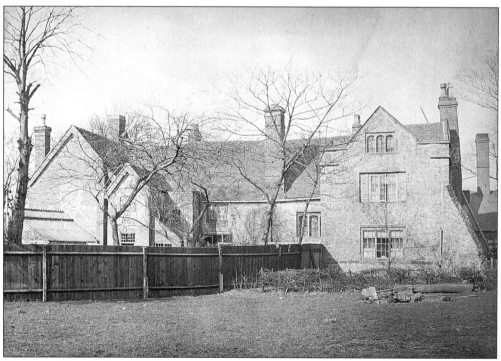

The rear of Hay Hall, c. 1935.

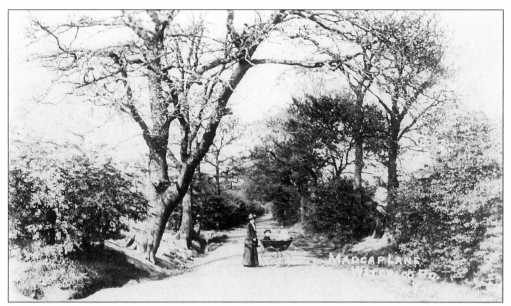

Madcap Lane, c. 1890. Also known as Madcat Lane, this became Graham Road when built on. Why the earlier names were given to it is not known. The Graham family started Yardley Stud Farm, and George Graham and his family moved to the Oaklands by the Coventry Road in the 1870's.

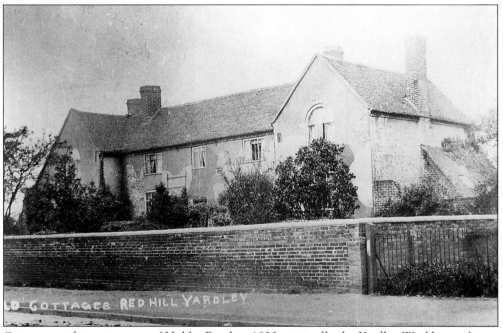

Cottages on the east corner of Holder Road, c. 1920, originally the Yardley Workhouse. It was built in 1808, and served as such until 1839. It was converted into these cottages, which were demolished c. 1960.

The old canal bridge, Stockfield Road, 1924. The bridge was replaced in 1926, as part of road widening.

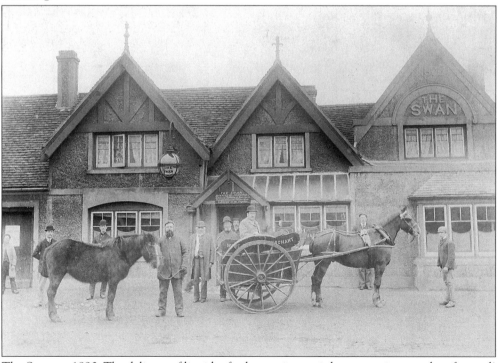

The Swan, c. 1890. The delivery of liquid refreshment is certainly an occasion worthy of record!

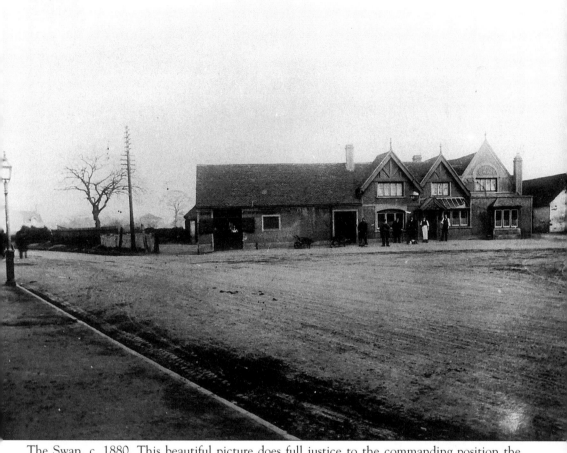

The Swan, c. 1880. This beautiful picture does full justice to the commanding position the Swan had at the junction of Yardley Road and the Coventry Road. It was not just a place to have a drink: meetings and fund-raising events were held here. It was also a coaching inn. This was the true focal point away from the village, and lasted as such in local memory up until the present day. The Jennings family, the licensees, used to have a slaughterhouse behind: hot weather must have been an experience. There may well have been an inn there before 1605.

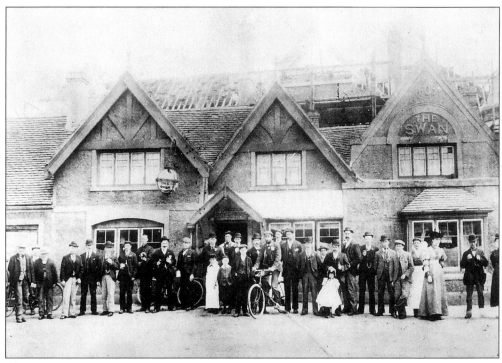

The new Swan taking shape, 1898. The new Swan was built behind the 1605 pub in order to attract people walking out into the country from the new steam tram terminus at the Cole bridge.

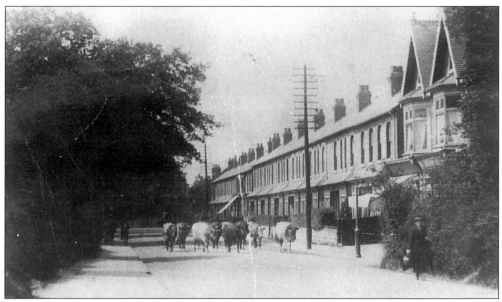

Yardley Road between Stockfield Road and the Swan, c. 1920. This is a surprising mixture of husbandry and recent terraces. Pinfold (Mansfield) Farm on Mansfield Road nearby still had a couple of years to go. The farmhouse and outbuildings are listed.

Clay Lane, c. 1910. At this time, no dwelling was to be seen from Woodcock Lane until Kingsley House near the Coventry Road.

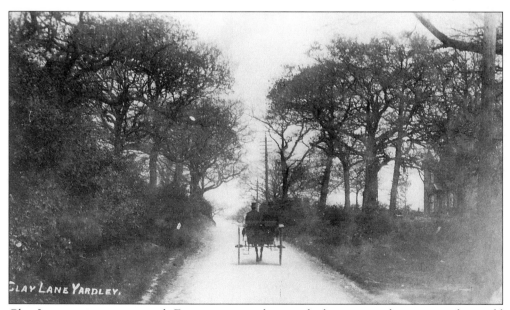

Clay Lane again, same period. Fortunate were those with their personal transport who could enjoy an outing in such surroundings.

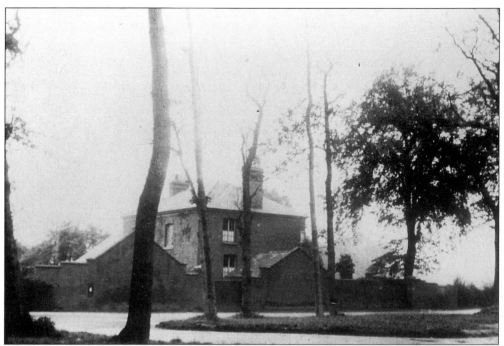

Yew Tree House, c. 1925. This stood on the right side of Church Road just before it met Yew Tree Lane.

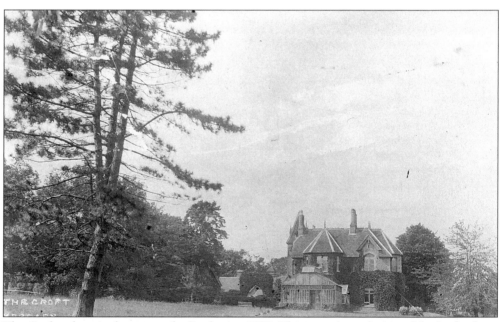

The Croft, otherwise known as the Poplars, c. 1920. This is a postcard view of the back of one of the local mansions. Mrs. V. Boston wrote that she lived there from 1916-23. Charlbury Crescent, Welford Avenue and Cranfield Grove stand within the grounds. The Lodge still stands on Lodge Drive, off Barrows Lane.

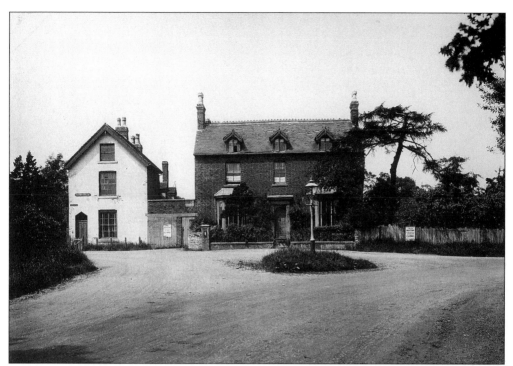

Marlborough House and The Retreat, 1925. These stood at the junction of Blakesley Road, Stuarts Lane (Road) and Clements Road.

The old Malthouse with Yardley church in the background, c. 1920. This view of Stoney Lane can be compared with the one on page 61. The Malthouse was still standing in 1950.

Blakesley Hall, 1924. The Common Good Trust bought it and gave it to the City in 1932. It became a museum, but it and the cottages seen here suffered bomb damage in 1941. After six years of repair and restoration it re-opened in 1957 without the cottages, and was restored to its 1684 appearance in the years around 1980.

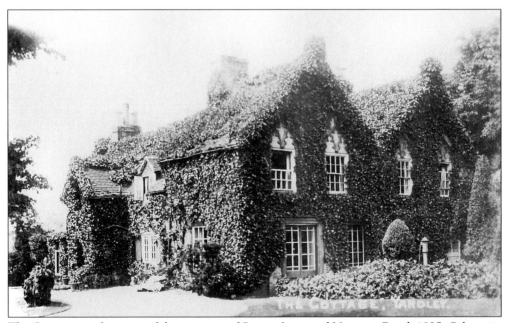

The Cottage, south corner of the junction of Stoney Lane and Vicarage Road, 1925. Otherwise known as May Villa or May Cottage, this house was already standing in 1812. It was a victim of inter-war road widening.

Vintage Cottage, east end of Blakesley Road, 31 December 1936. Sadly, this 17th century house was demolished in 1964. The sign offers cut flowers for sale.

The rear of Vintage Cottage.

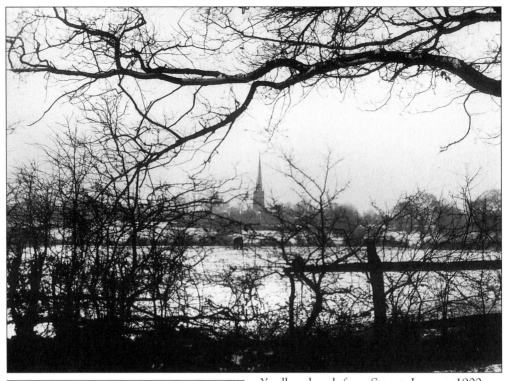

Yardley church from Stuarts Lane, c. 1900.

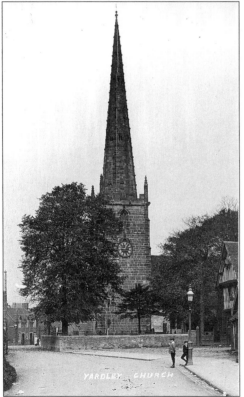

Yardley Church, c. 1910. The church has two unusual features. There are scraped incisions on the tower base, which may be sharpening marks or even where an old version of confetti was scraped off! The Tudor Rose and Pomegranate in the North Aisle doorway represent the brief marriage of Prince Arthur, son of Henry VII, and Katharine of Aragon. History might have been very different if he had not died.

The church moat or Rents Moat, 1939. This was the manor house moat. After local opposition to proposals for housing nearby in 1937, the moat and land to the churchyard were fenced off and declared a bird sanctuary. The moat has since been filled in, but its outline can be seen.

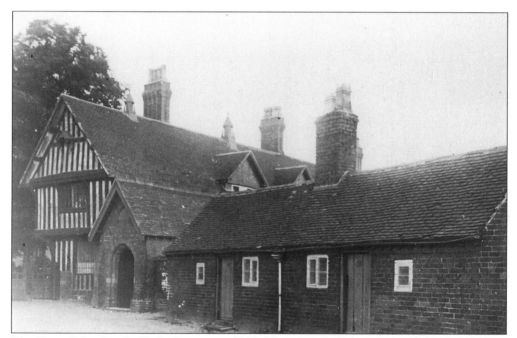

The Trust School and old almshouses, c. 1900. The new almshouses beyond the church were built in 1903, and the ones shown here, dating from around 1800, were demolished several years afterwards.

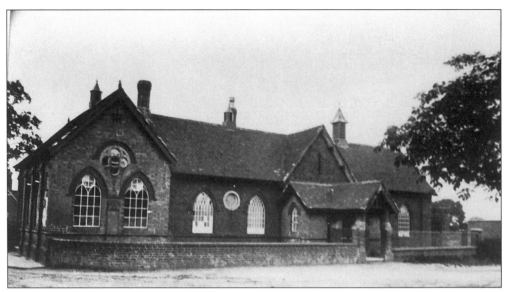

Yardley Church Girls School, c. 1900. This dates from 1832, originally as a Sunday school. It and the Trust School were forced to close in 1908, and all children went to Church Road. The windows have been bricked up for a very long time, and extensive repairs were made 1955-8. It is used as a parish hall.

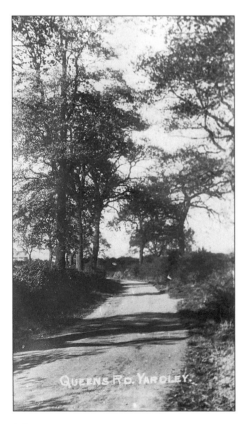

Queens Road, c. 1920. This used to be called Grove Lane after the house which stood along here.

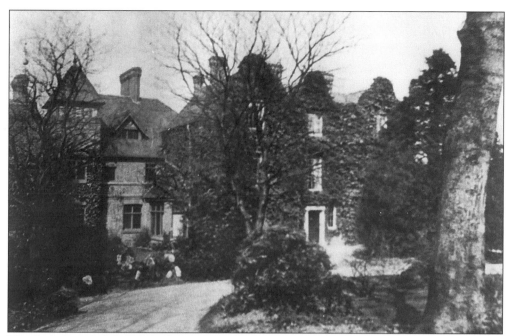

The Grove, c. 1910. Vibart and Farnol Roads occupy the site of this splendid house and grounds now.

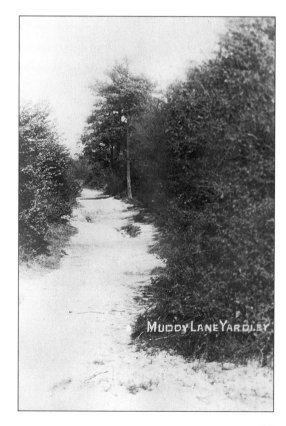

MUDDY LANE YARDLEY

Moat Lane, c. 1920. Undoubtedly picturesque, Moat or Muddy Lane as it was known as well, was the subject of complaints about refuse dumping and rats in the 1920's. See also page 120.

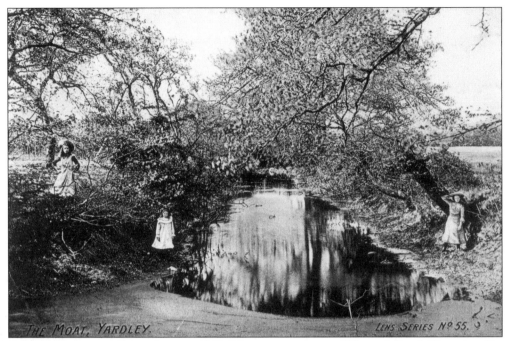

A beautiful picture of Moat Lane, c. 1905. The moat was west of Elmcroft Road. There is still a small open area to the lane. The only consolation is that there is a children's playground here now.

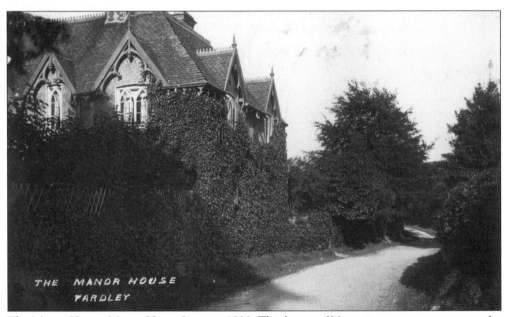

The Manor House, Manor House Lane, c. 1920. This house of Victorian appearance was on the site of the manor house of Lyndon, a detached part of Bickenhill Parish. Derringtons, who had a brickworks in Hay Mills until 1921, lived here from 1870 until the 1930's.

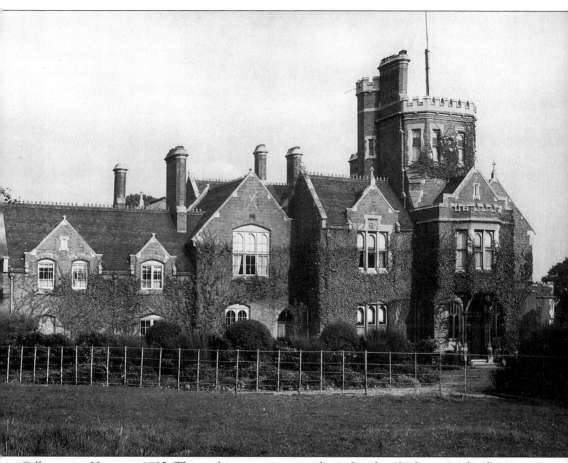

Gilbertstone House, c. 1935. This striking mansion was also in Lyndon. In fact an earlier house a short distance from here straddled the boundary. This house was built in 1866-7 for Samuel Thornley: no expense was spared. It was later bought by Richard Tangye, who was a major benefactor to the City Art Gallery. It had extensive grounds with a pool and boathouse. The tower was 65 feet high, and the views of the countryside around were said to be magnificent. Thomas Rowbotham the builder lived here while developing the roads nearby (see page 59). He also gave land for the building of St. Michael and All Angels church, although that piece was eventually exchanged for the site the church was actually built on. Sir Hanson Rowbotham sold the estate for £250,000, and the house was demolished by 1937. The west end of Saxondale Avenue is the house site, and the grounds covered half of Sunnymead Road and parts of Wensley Road, Brays Road, and Wychwood Crescent.

Lyndon Green Farm, 1933. Built in the 17th century, it was known locally as Eades Farm. They lived there from 1912 until its demolition in 1939, and were a familiar sight delivering milk in Sheldon, Small Heath and Hay Mills.

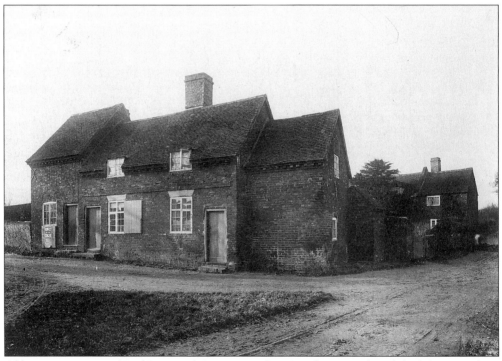

Old cottages, corner of Pool Lane and Queens Road, 1938. They were demolished the year after.

Two
Suburban Scenes

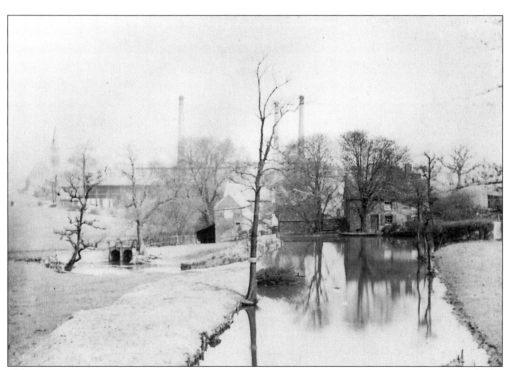

Hay Mill, c. 1920. This beautifully composed view was taken by Thomas Capel Smith, who worked at Latch and Batchelors in Hay Mills. He was also a photographer and had a studio, the Mirror Studio, in Gladys Road. Eight postcard views in an envelope cost one shilling. See the acknowledgements for other photographs by him included in this book.

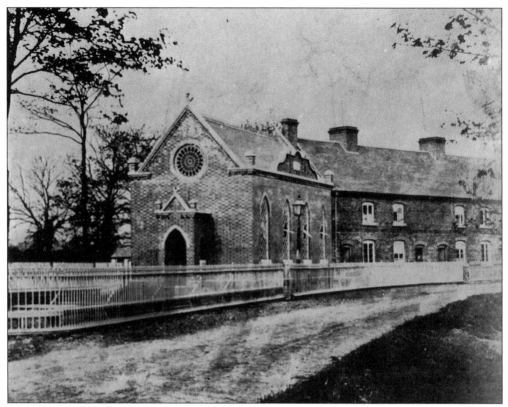

St. Cyprian's old schoolroom and chapel, c. 1870.

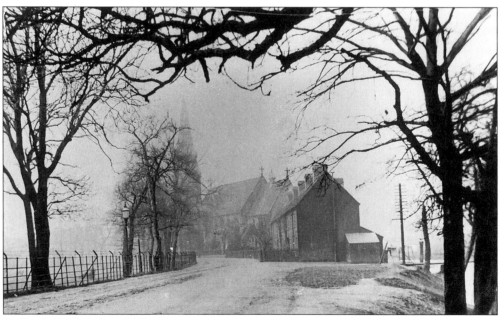

St Cyprian's church, c. 1920.

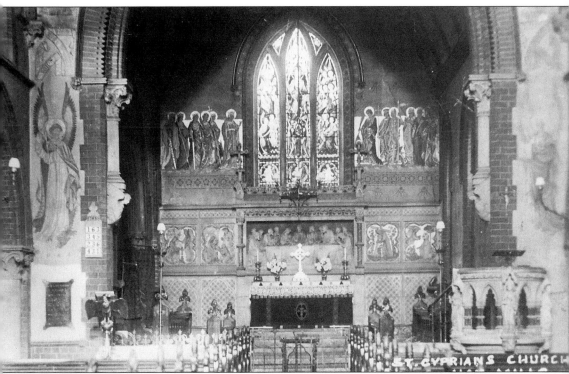

Interior of St. Cyprian's. Webster and Horsfall came to Hay Mills in 1853, and built cottages for the workers they had brought with them, They also built a schoolroom in 1860. It was converted into a chapel and a new schoolroom was built. The chapel proved too small, and a new church was built and opened in 1874. It had this fine reredos of 1875. Unfortunately a World War Two bomb badly damaged this end of the church and destroyed two of the cottages, and the 1950 restoration is not as fine. The bell at St. Cyprian's bears the date 1749. It was the former tannery bell, and was given by George Muscott to St. Chad's church, from where it went to St. Cyprian's.

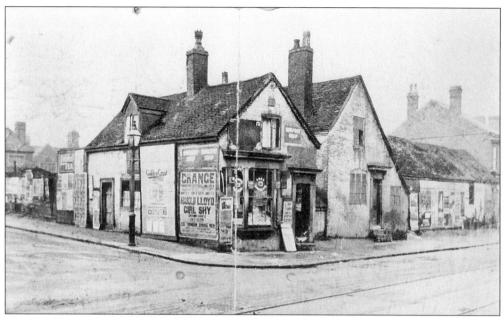

Shops at the corner of Redhill Road and Coventry Road, c. 1910. Edward Fagg's corner shop used to be Redhill Farm. The cottages to the right were formerly tile sheds, here they are a blacksmith's premises. All this was demolished when the Redhill pub was built.

Laying of the foundation stone, Hay Mills Congregational church, 1899. The church was at the corner of Kings Road and the Coventry Road, and was demolished in 1984. The congregation went to St Chad's.

Gladys Road, Hay Mills, c. 1920.

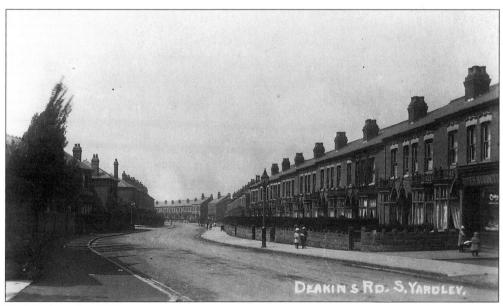

Deakins Road, c. 1910.

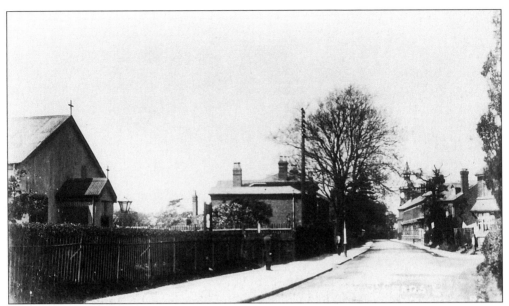

St. Chad's and Waterloo Road, c. 1925. St. Chad's was built by St. Cyprian's, who sold it in 1984. This 1907 Mission Hall was replaced by the brick church of 1935. This postcard was produced by Redhill Post Office.

Waterloo Road, 18 February 1935. The camera is looking towards Coventry Road.

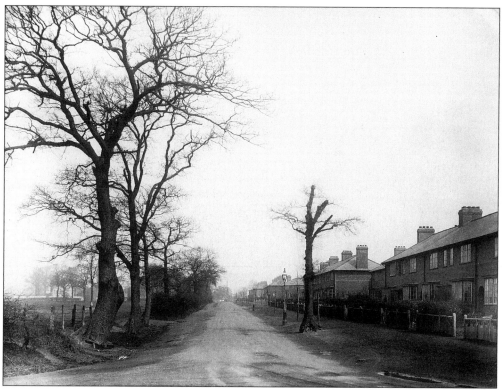

Graham Road, 16 April 1931. The Broadyates estate was built in 1924, and the Hilderstone estate in more attractive brown brick followed in 1935.

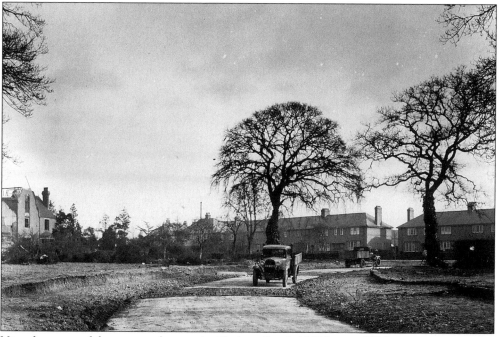

View from one of the new roads opposite Graham Road, 18 February 1935.

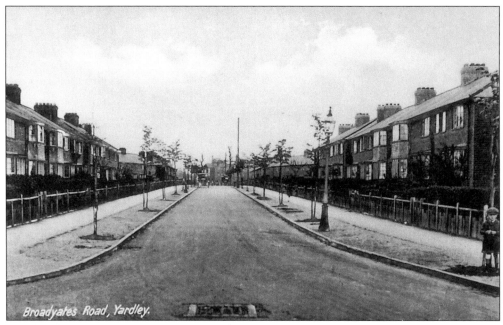

Broadyates Road, c. 1930. Council estate roads were definitely worthy candidates for postcards at the time.

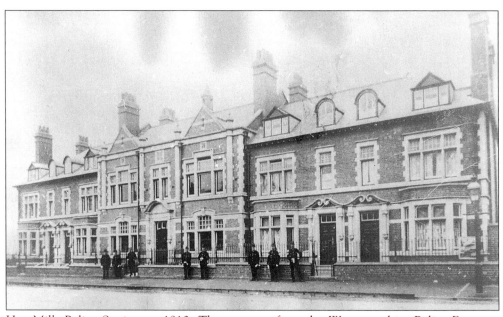

Hay Mills Police Station, c. 1910. The men are from the Worcestershire Police Force, as Yardley was in Worcestershire until 1911. This is now a pub, the Old Bill and Bull.

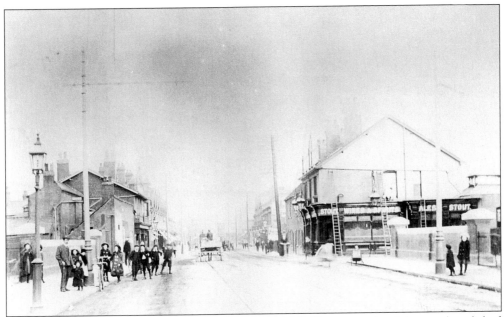

Coventry Road at Hay Mills Bridge, 1904. The Hay Mills Tavern on the right was demolished in 1983.

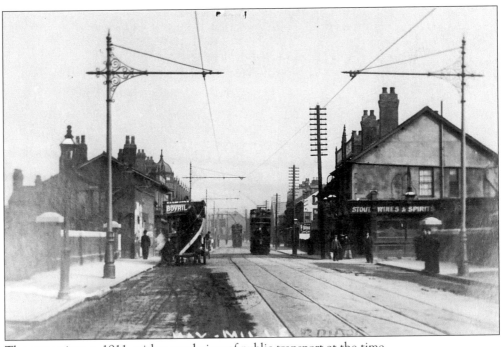

The same view, c. 1911, with a good view of public transport at the time.

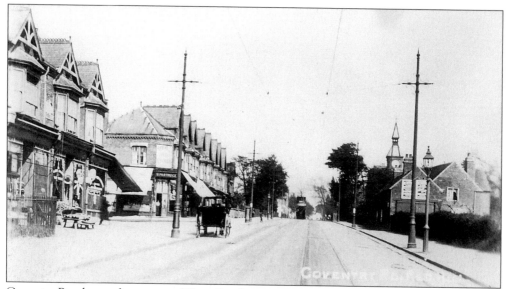

Coventry Road near the corner of Flora Road, c. 1920.

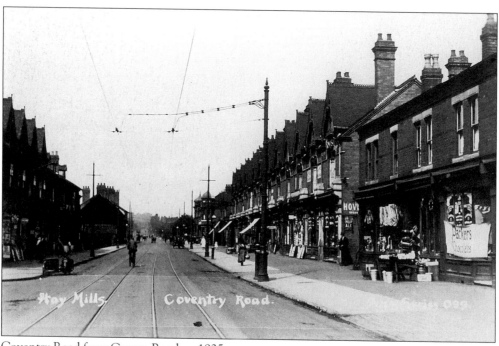

Coventry Road from George Road, c. 1925.

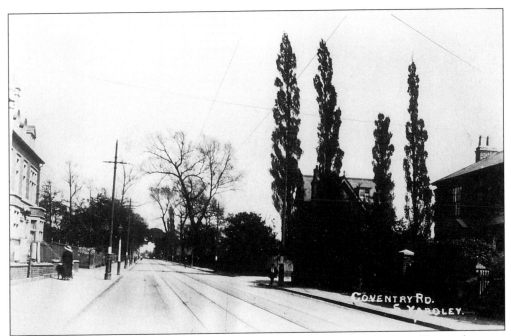

Coventry Road by Holder Road, c. 1910. The centre of this scene is visible in the next photograph.

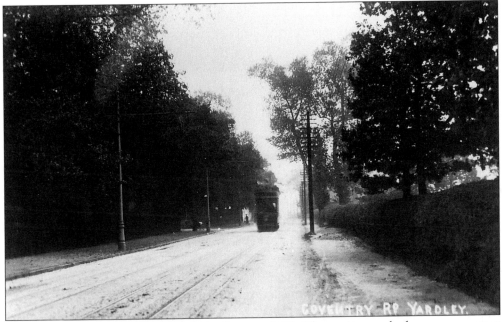

Coventry Road from Holder Road to the Swan, c. 1905. The continuous hedgerows are a great contrast to what can be seen today!

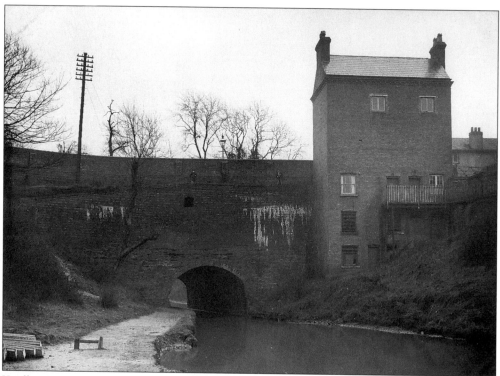

Yardley Road canal bridge 5 March 1934, with two boys perched precariously three quarters of the way up.

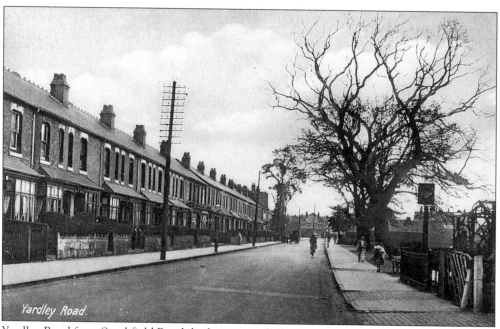

Yardley Road from Stockfield Road, looking towards the Swan, c. 1930.

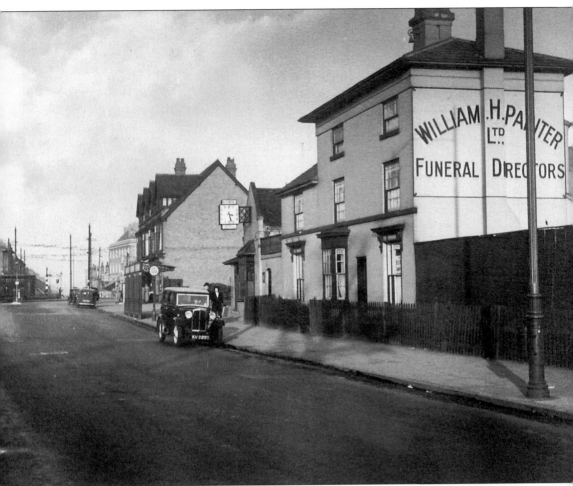

Yardley Road near the Swan, October 1938. Henry Painter began a coach hire business across the junction in 1897. William H. Painter, his son, offered on the spur of the moment to conduct a funeral for a friend, got recommendations and further business, and set up formally in the same premises in 1907. In 1926 they moved to the building seen here, and they then built new premises behind. They continued with their business of hiring out horse-drawn vehicles, and several photographs of their family and business activities are included in this book.

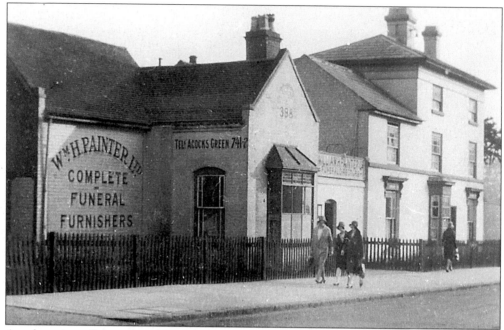

Another view of the office. This building was known as Rose Villa or Rose Cottage. W. H. Painter sold the land adjacent to his new premises to the City, and South Yardley library was built there. The monkey puzzle tree still stands.

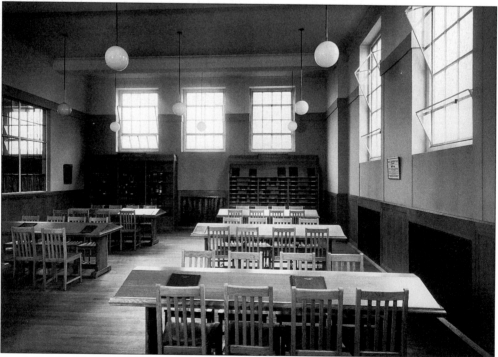

South Yardley library was opened on 15 March 1939. This is the newspaper and magazine room. The notice warns: No Conversation. This room is now carpeted and is a thriving 'community' room, with coffee mornings, lectures, meetings and concerts.

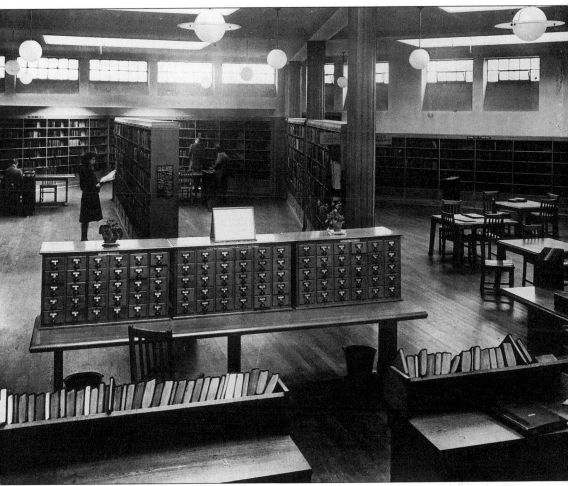

The Junior Department is to the right, and looks bare and uninviting to modern eyes. However, the library is a fine example of 1930's design, and the entrance hall and interior columns are particularly attractive. On entering the library you get a satisfying feeling as the view of the shelves opens out before you. Despite being such a large building, the easiest way to tell people where it is located is to say that it is next to Painter's. In fact, until it acquired its large new sign, some people used to think that the library was part of the undertakers!

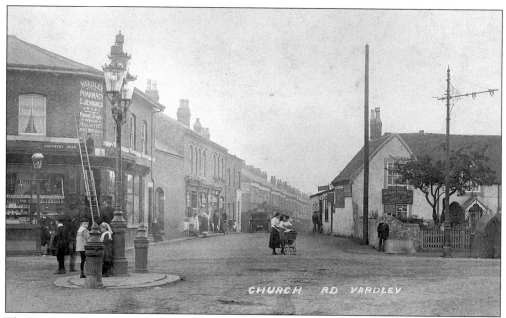

The Swan junction, c. 1912. Yardley Pharmacy is on the left, offering the Purest Drugs, Invalid Requisites, and Photo Materials. Painters premises are on the right.

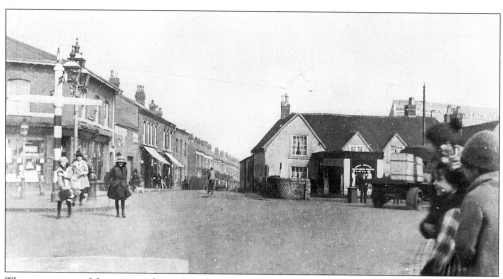

The same view, fifteen years later. Harding's Bakery took over the site vacated by W.H. Painter, c. 1927. They delivered bread by horse-drawn van far and wide, even as far as the Lickey Hills! Along Church Road there was a row of rather ugly chimneys. The bakery site and shops fronting it were sold to the City in 1960 in advance of redevelopment.

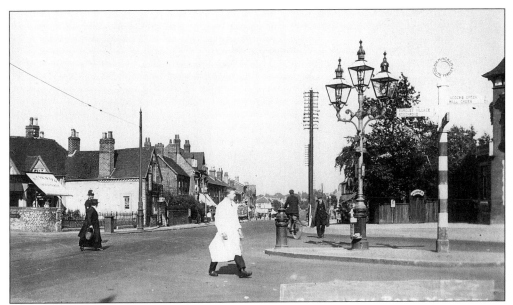

Looking down the Coventry Road from the Swan junction, c. 1925.

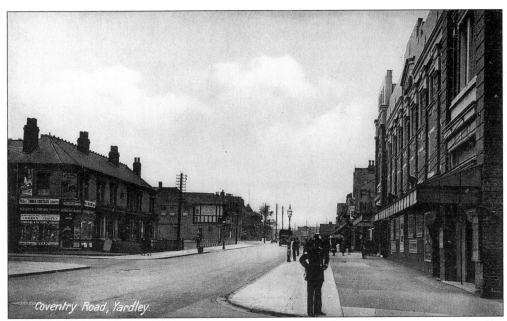

The New Inn (left) and the Tivoli cinema (right), c. 1930, looking back towards the Swan. The 1960's road widening saw the 1895 New Inn's demolition but it continued as a prefab known locally as "The Shack" until 1983, when a new pub was built. The Tivoli cinema was in business from 1927 to 1961.

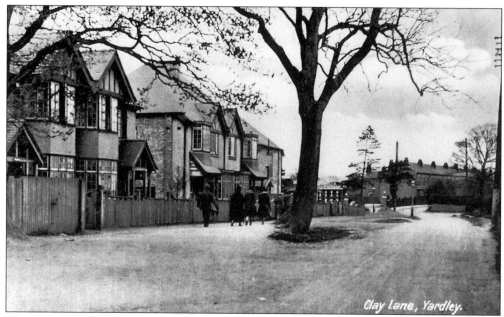

Clay Lane by the Coventry Road, c. 1930.

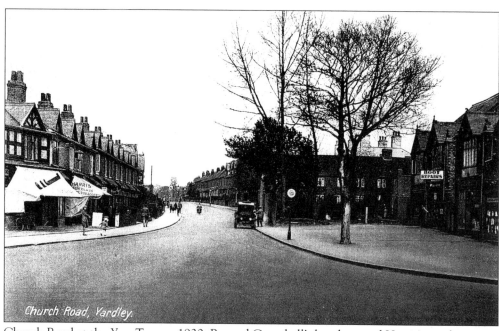

Church Road at the Yew Tree, c. 1930. Beyond Campbell's butchers and Harris's confectioners were other shops and a laundry. Payne's boot repairers this side of the butchers were faced by Ernest Albert Tullett, boot dealer, on the right.

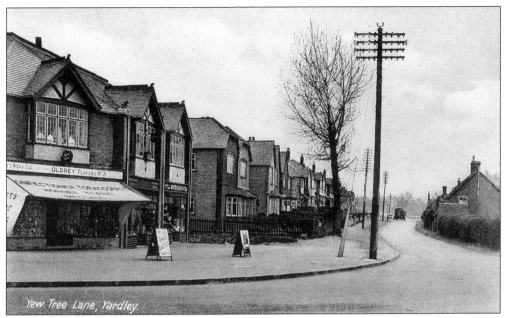

Yew Tree Lane, c. 1930. These shops that year were Oldrey's confectioners, G.E. Green, wireless accessories, and Edith Whitehurst, hardware dealer. Valerie Blick (page 120) remembers as a small girl being frightened by the sight of cows being moved past her house down the lane from Holly Farm on the right.

Rowlands Road, 1924. The workmen's hut belongs to Thomas Rowbotham, builders and engineering contractors. St Michael's Mission church opened across the road from these houses in 1930.

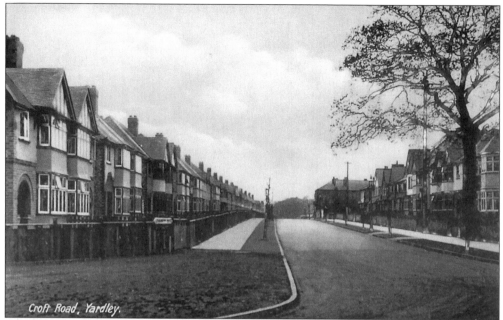

Croft Road, c. 1930.

Church Road, 19 March 1937. From 1933 to 1989 the Grange, on the right, was a Carmelite convent. The house is 16th and 17th century with substantial Victorian additions. A house between the convent and the new Ring o' Bells was removed for its car park in 1938, but the pub's proximity apparently did not worry the nuns!

Church Road by Yardley Fields Road, 31 January 1937. Church Road Farm is on the left.

Stoney Lane by the Malthouse garage, 30 July 1925. This view can be compared with the one on page 31.

Stoney Lane at Blakesley Road, 6 June 1924: 'before'.

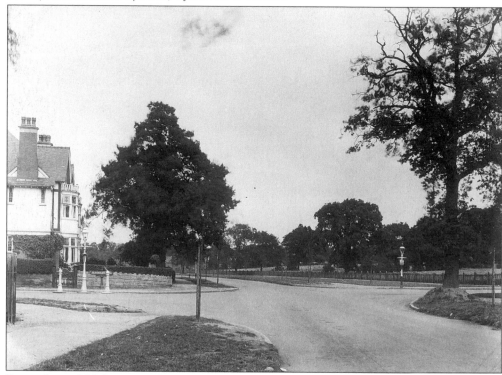

Stoney Lane, 30 July 1925: 'after'. Lighting was provided first on lanes, and proper surfacing and pavements came later.

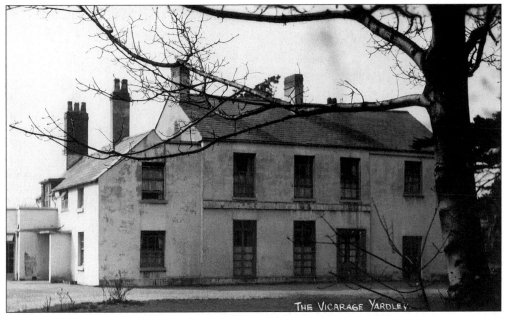

Yardley vicarage, c. 1930. This was replaced by a smaller building in 1960.

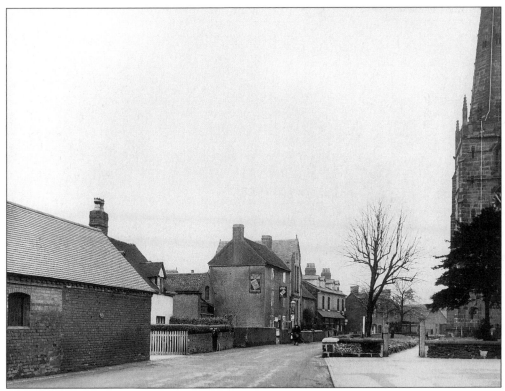

Approaching Yardley Village, 31 December 1936. On going there today, it is apparent how little the Village has changed in sixty years.

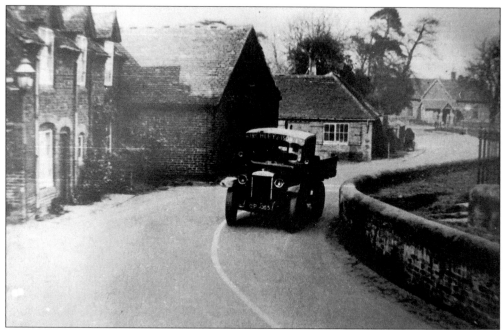

A truck belonging to Birchley and Ison coming through the Village, c. 1937. Through traffic ceased in 1976.

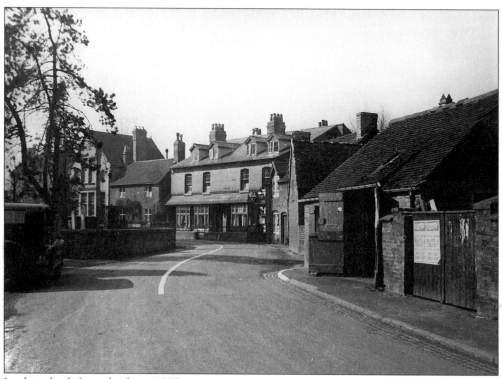

Looking back from the farm, 1935.

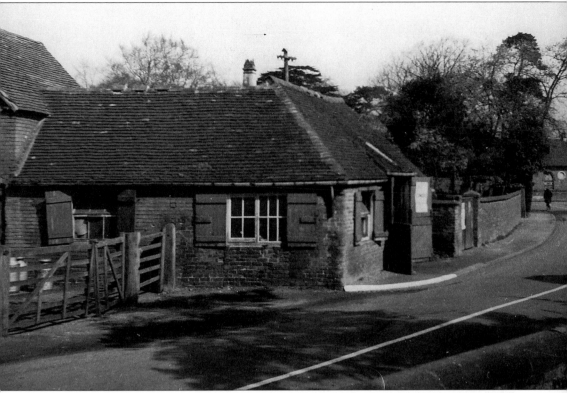

The smithy at Yardley Farm, 1935. The Village has been a Conservation Area since 1969. Apart from the church and schools, it contains a variety of buildings from several periods. The oldest dwelling dates from c. 1710 and became a butcher's shop in the 1850's. The earliest of the farm buildings date from the 1820's: the farmhouse itself is from 1837. There is no farmland any more. The Cottagers' Institute of 1882, the 1826 brick cottage built for the blacksmith, 1890's terraces, and an 18th century malthouse converted into cottages around 1850 are just some of the buildings here. Planning restrictions are in force, but the Yardley Conservation Society maintains a constant vigilance to ensure nothing out of keeping is passed. The Historic Buildings Council has given the area the category Outstanding.

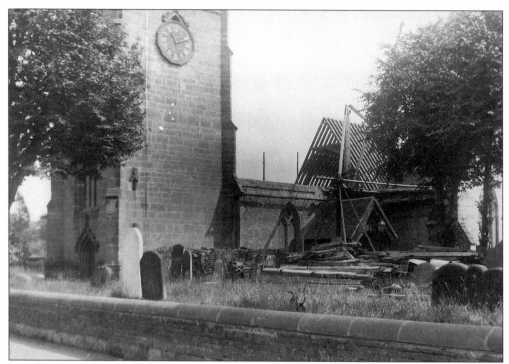

Yardley church, 1926. The roof, worm-eaten, in an advanced state of decay and dangerous, was replaced that year. The church was closed from April to December. Services were held in the parish hall after gnats from the moat thwarted attempts outdoors in the churchyard.

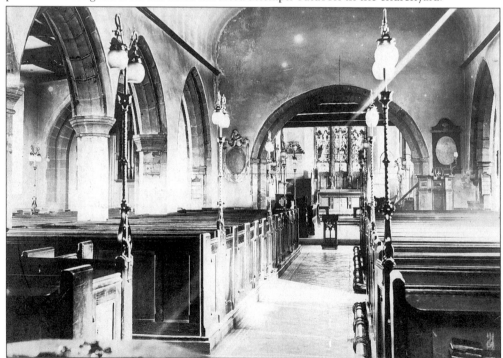

The nave before restoration.

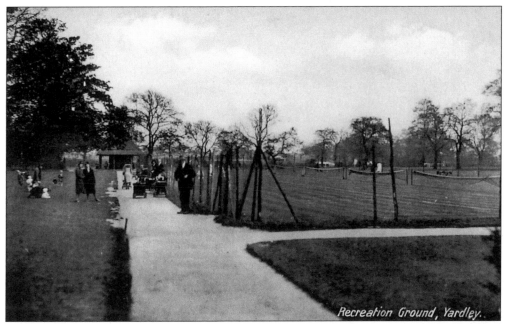

Yardley Recreation Ground, c. 1930. Several recreation grounds, including this one, were formally opened on the same day in 1902 to celebrate Edward VII's coronation. The Revd Sutton Dodd officiated here. The land had been transferred to Yardley R.D.C. by Yardley Great Trust in 1898, although the deeds were not handed over until 1900.

The Manor House, c. 1939. The ivy and the Derringtons have gone. Builders occupied the house after them, and it was demolished c. 1961 to make way for maisonettes.

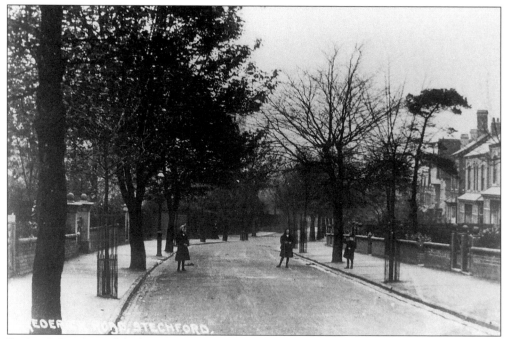

Frederick Road, Stechford, c. 1920.

Mary Road, Stechford, c. 1910.

Three

Transport

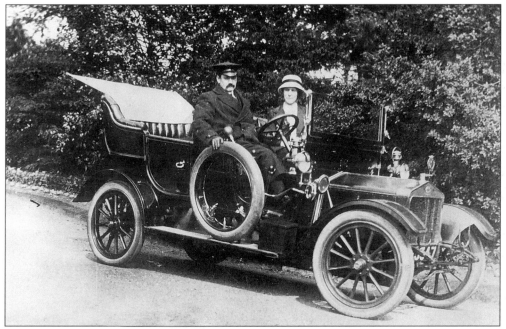

Homer Muscott's wife with chauffeur, c. 1930. The Muscotts owned Yardley Tannery: several photographs of it can be seen in the section on Yardley at work.

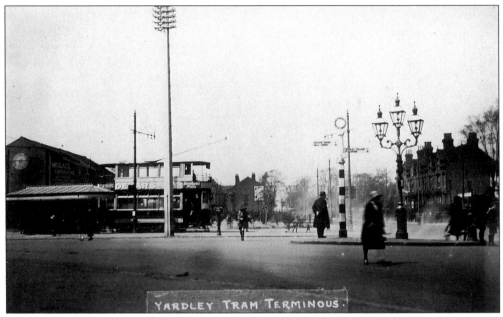

Yardley Tram terminus, c. 1915, looking west. B.M.C. to the left of the tram became Colliers in 1926. By now the terminus had a loop, rare in Birmingham. The trams used a diesel-powered generating station here from 1904 until around 1912.

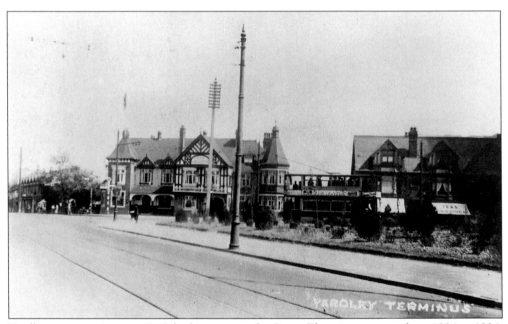

Yardley tram terminus, c. 1915, looking east at the Swan. Electric trams ran from 1904 to 1934. An open market was held near the terminus for a number of years until 1920.

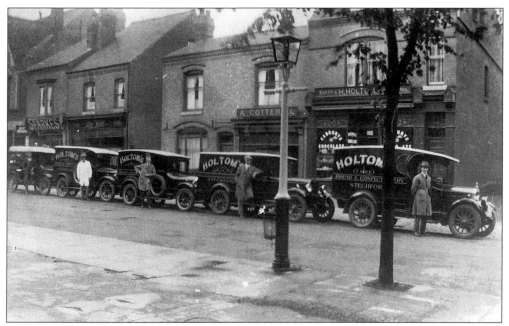

H. Holtom's bakery vans, Albert Road, Stechford.

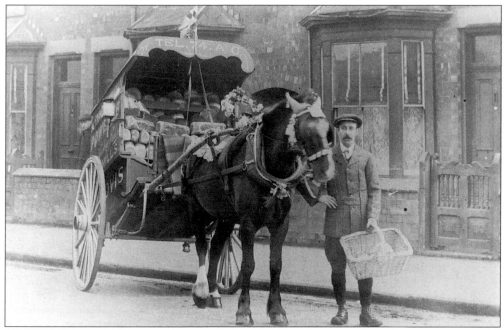

Powell's bakery cart: the bakery was on the Coventry Road, Hay Mills.

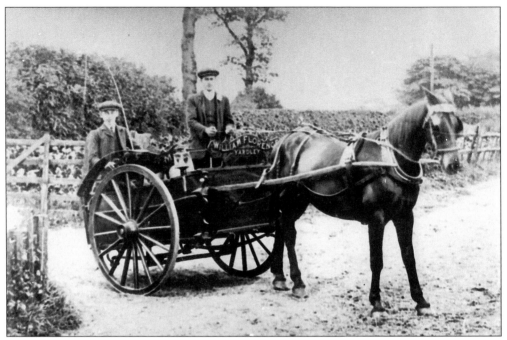

Frederick and William Florence of Hay Hall Farm, c. 1930.

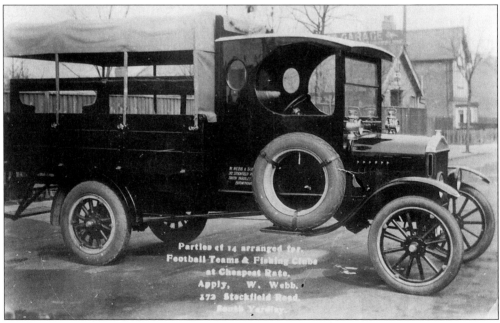

A lorry converted into a coach for hire, from W. Webb of Stockfield Road, late 1920's. Apart from hiring out vehicles, Webbs were also grocers, timber merchants and builders. Around 1931 they left Stockfield Road for a timber merchants yard at Yardley Road by the cemetery, where they offered rustic work.

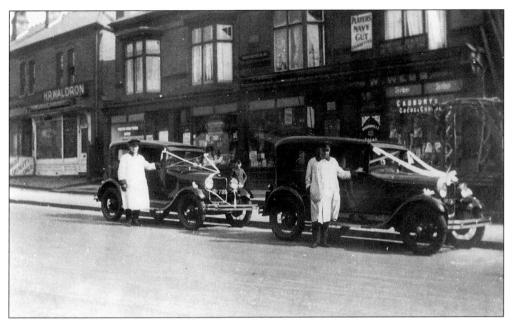
Hire cars outside Webbs, 1920's.

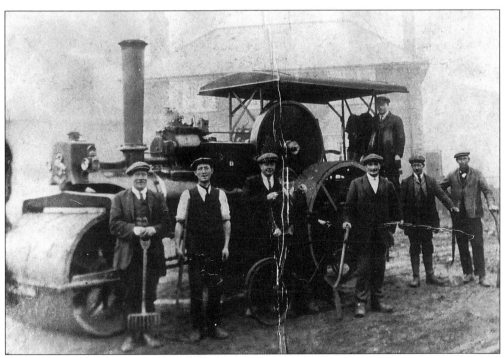
A road roller in Berkeley Road, Hay Mills.

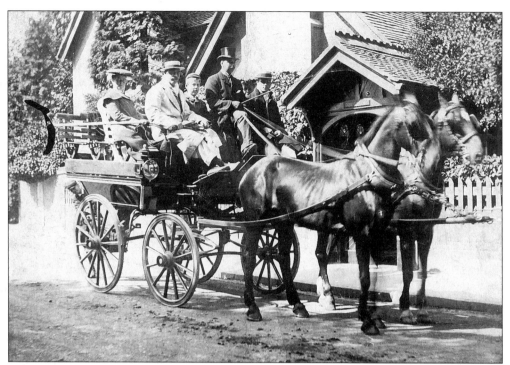

A summer outing from the Grange, 1906. Ebenezer Hoskins, bedstead manufacturer, lived here. He built the Cottagers' Institute in the Village for adult education. This picture was taken by H. Ronald Hoskins.

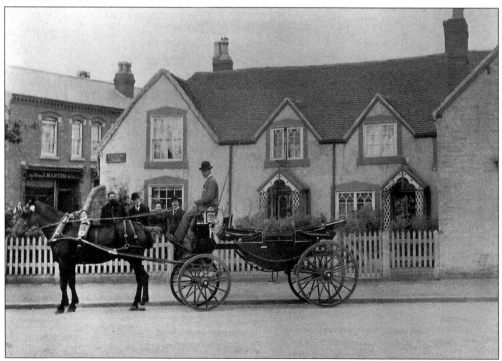

A landau, c. 1897. William Painter is the driver.

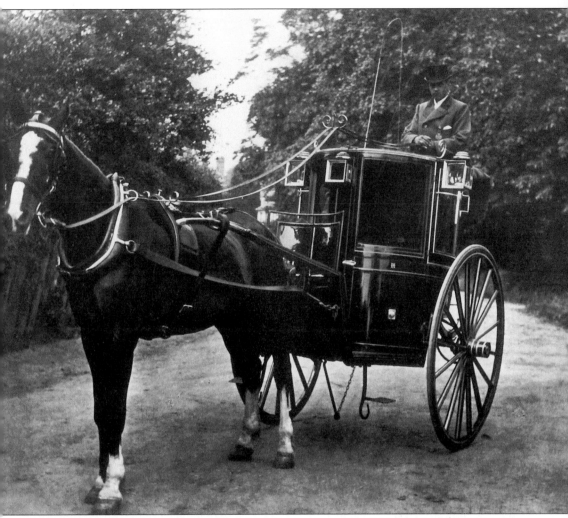

A hansom cab belonging to Painters. They hired out various splendid horse-drawn vehicles for weddings, other functions and trips. A selection of them and their funeral vehicles follows. Painters were set up to service these operations at Yardley Road with stables, a harness room, and a smithy on site. In fact, the wrought-iron gates which adorn their frontage so impressively were made there.

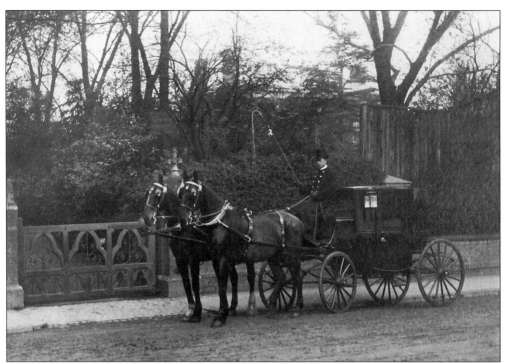

A brougham at Church Road.

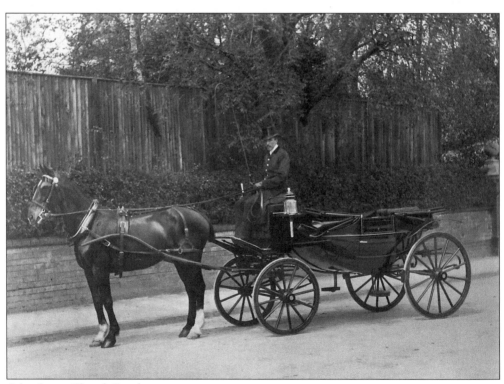

A landau at Church Road.

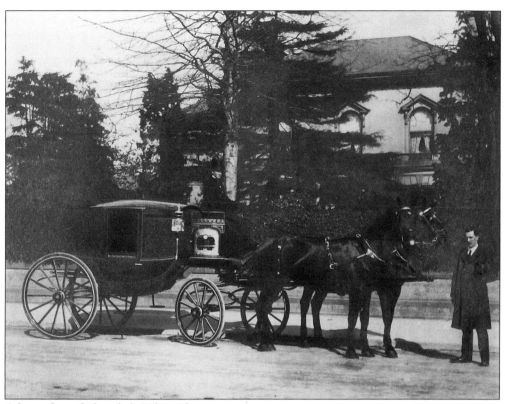

A booted coach for a baby's funeral.

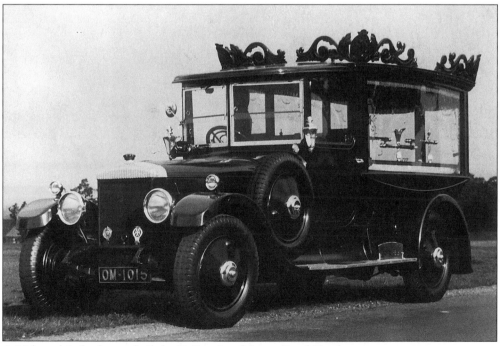

A 20 h.p. daimler hearse built by T. Startin of Aston Road North.

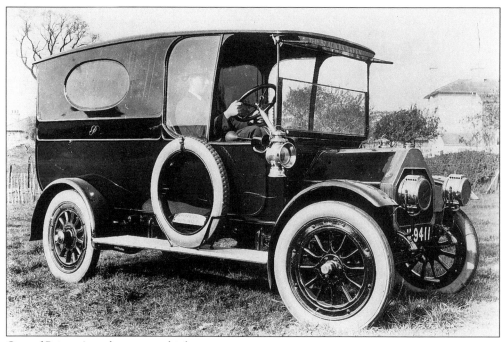

One of Painter's early motor vehicles.

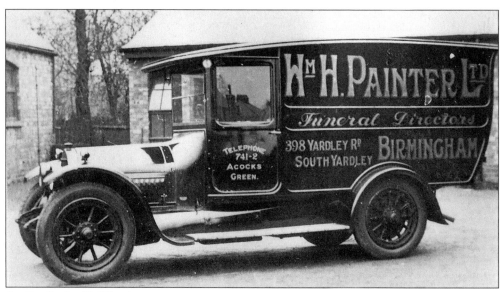

An 8-cylinder Cadillac hearse.

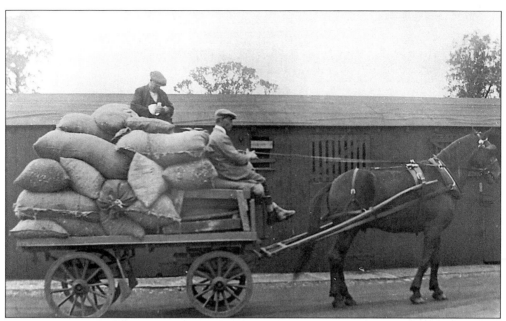

A wagon arrives with feed for Painter's horses.

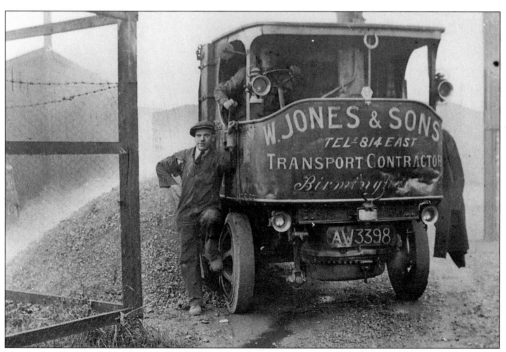

Repairs to Painter's yard, c.1930. W. Jones and Sons were at Lichfield Road, Aston.

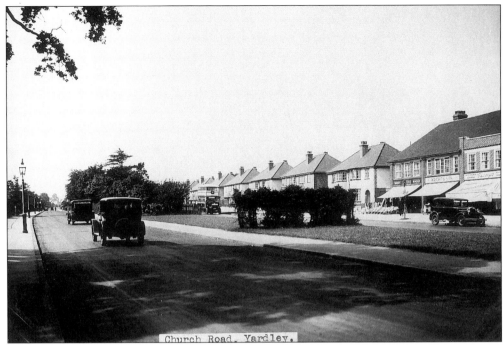

Church Road. Yardley.

Church Road from the Yew Tree, 1931. The rest of Church Road to the Swan junction is still awaiting widening. Motorbuses were the first public transport to go near Yardley Village, from 1923, on part of what became the new Outer Circle route in 1926.

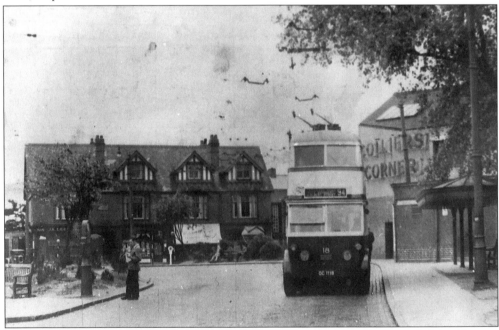

A 94 trolleybus waits at Colliers Corner, c. 1938. From 1936 the 94 route extended the 92 route to the city boundary at Arden Oak Road, Sheldon, replacing a motorbus route operational since 1931, when Sheldon had become part of the City. Motorbuses replaced all Coventry Road trolleybuses from July 1951.

Four
Yardley at Work

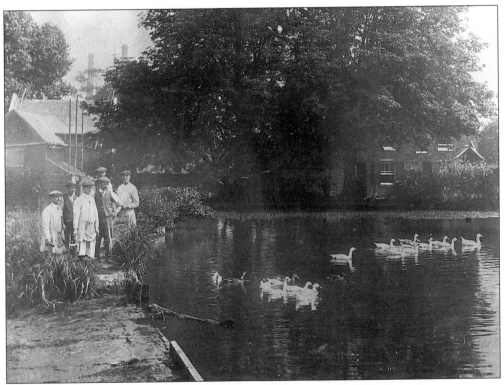

Workers at Hay Hall Farm (Florence's Farm), c. 1920.

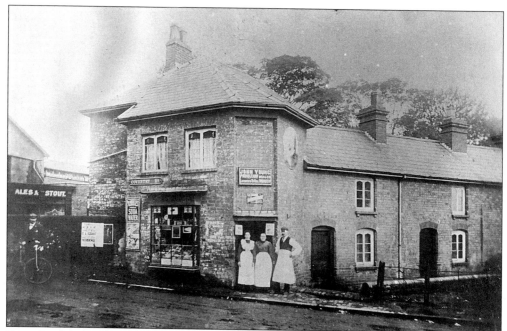

Young's provision shop at the Cole, 1903. The river is between the shop and the pub. The same year, this former tollhouse was demolished when a new, wider bridge was built. That bridge is now the Old Bridge 1903 spanning the out-of-town carriageways only.

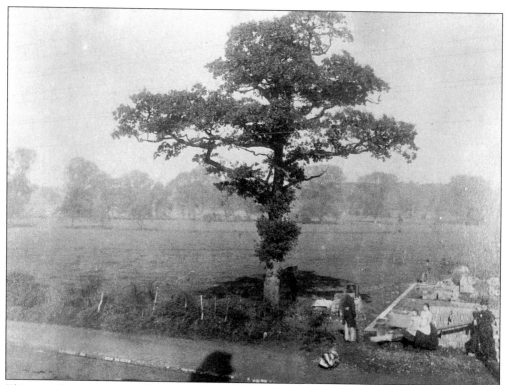

This is said to be a photo of shops being built on the Coventry Road in the 1880's.

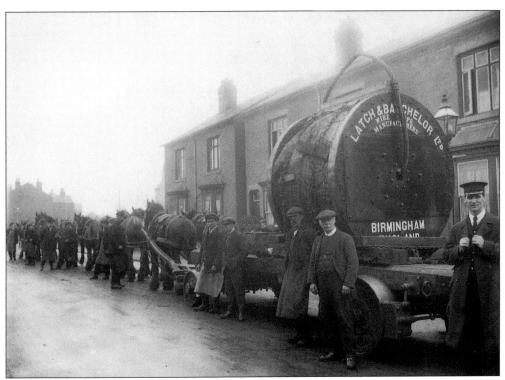

A mining cable being pulled along Kings Road to Tyseley station, c. 1915.

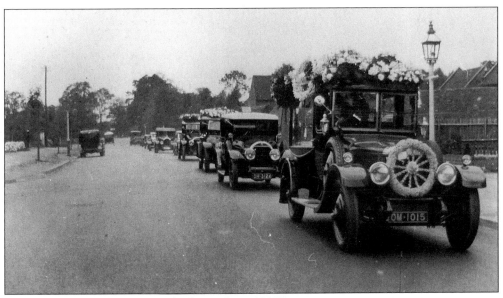

A funeral cortege of Painter's vehicles, perhaps 1930's.

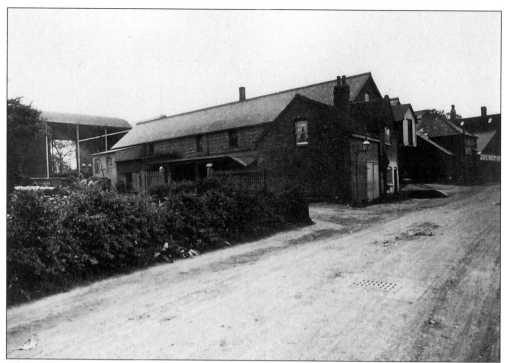

Yardley Tannery, Amington Road, c. 1900. George Muscott came here in 1884, and the company produced high quality shoe leather until the mid-1960's. The smell was terrible, but local children with whooping cough and chest problems were apparently brought nearby to breathe in the fumes!

The bark barn at the tannery, c. 1900.

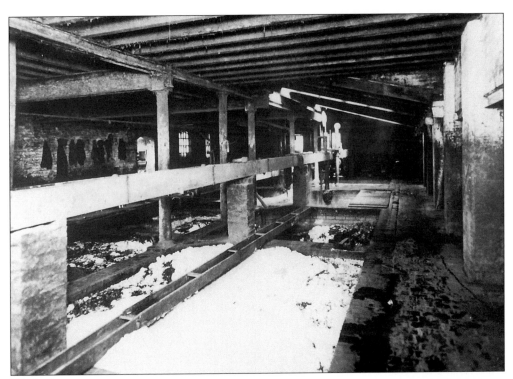

The bark pits.

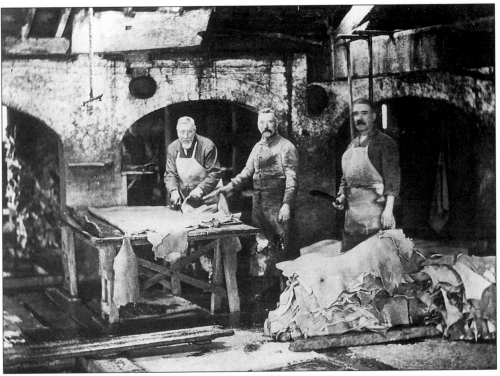

Cutting the leather (George Muscott is at the bench).

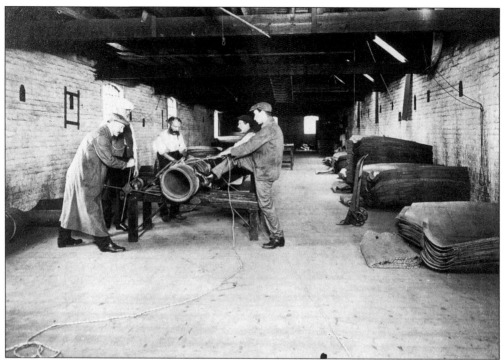

Tying the leather.

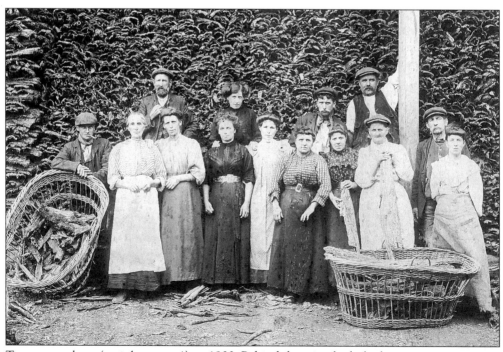

Tannery workers, (mainly women!), c. 1900. Behind them is a bark shed.

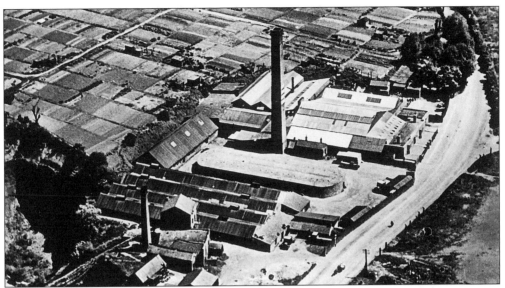

A company postcard advertising Bayliss' Brick Works, Speedwell Road, Hay Mills, c. 1920. Bayliss had bought the site from Hemmings by 1913.

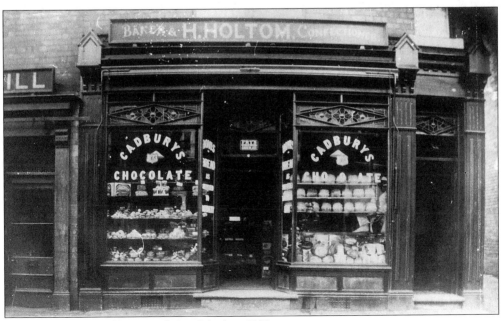

H. Holtom's shop, Albert Road, Stechford, c. 1930.

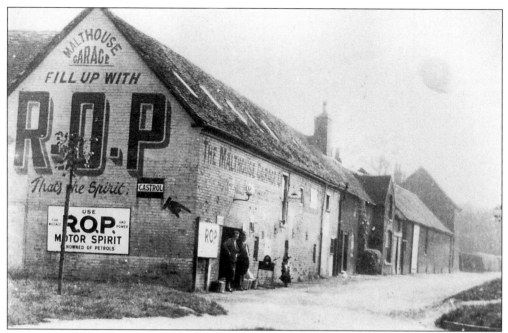

A close-up view of the Malthouse Garage, Stoney Lane, c. 1925.

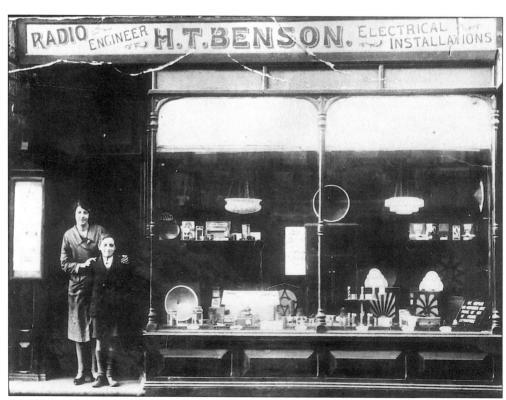

H.T. Benson's shop, 1 Kings Road, c. 1929.

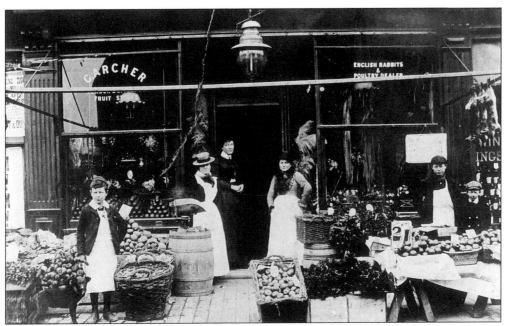

G. Archer's fruit and vegetable shop, 1094 Coventry Road, c. 1900.

Redhill Dairy at work in Hay Mills, c. 1920.

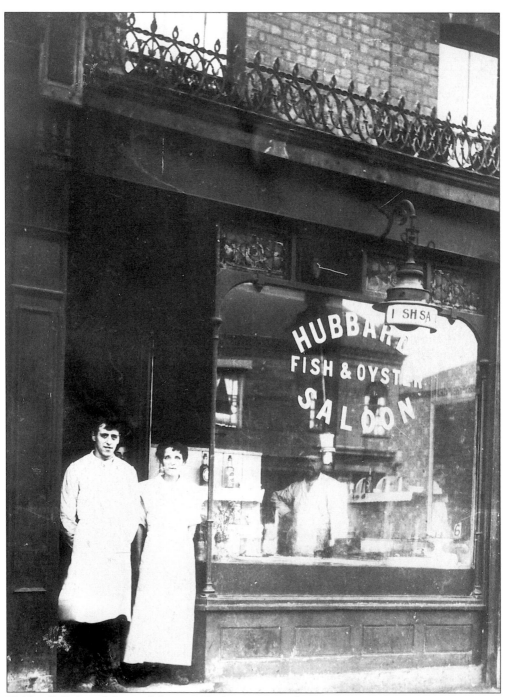

Hubbard's Fish and Oyster Saloon, 1057 Coventry Road, 1920.

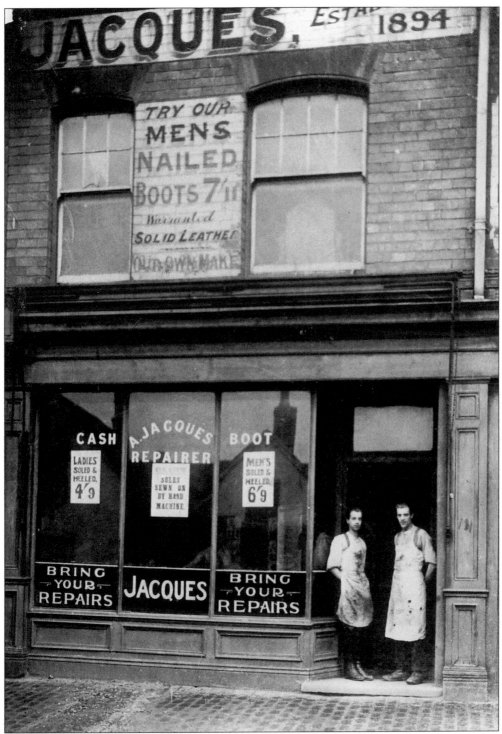

Arthur and Walter Jacques outside their boot repair shop, 1132 Coventry Road, c. 1924. See also the portraits on pages 126-8.

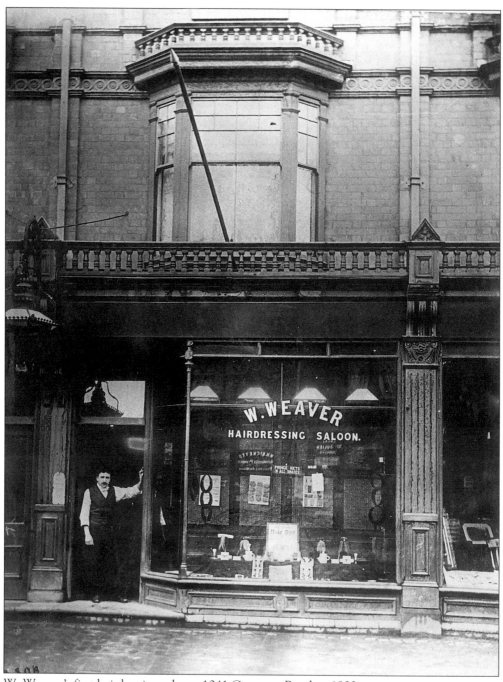

W. Weaver's first hairdressing saloon, 1041 Coventry Road, c. 1900.

Five
Yardley at Play

The Ring o' Bells, Church Road, 19 March 1937. The first Ring o' Bells was in the Village right opposite the church, where the Cottagers' Institute is now. This one opened c. 1860 and lasted until 1939. The new, larger pub was built behind it. Although it is grander, it is not as attractive. The old pub closed on 19 January 1939, and the new one opened the next day.

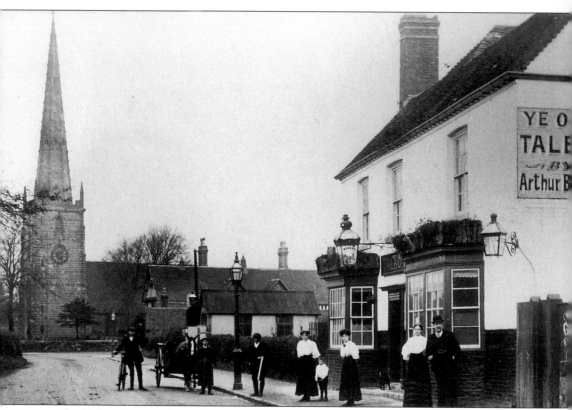

The Talbot Inn, Yardley Village, c. 1908. This 18th century inn remained in use until 1923. The Yardley Trustees used to meet there and distribute dole money. In 1924 Mitchells and Butlers sold it to the City, stipulating that it should never again be used for the sale of alcohol. Yardley fire station can be seen behind the inn. In the foreground the people have been identified as (left to right): the park keeper, the milkman, the blacksmith, two servant girls with the young boy, and the landlord and lady, Mr. and Mrs. Barrows. The Talbot became a confectioner's, then a tea room. It is now a private house.

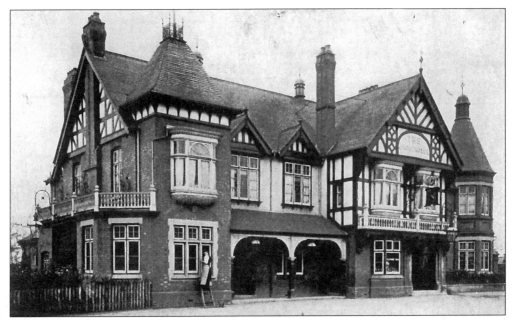

The Swan c. 1920. This second Swan lasted until the mid-1960's when the Coventry Road underpass was made. The third Swan, claiming to be the largest pub in Europe, has now been replaced by an office block.

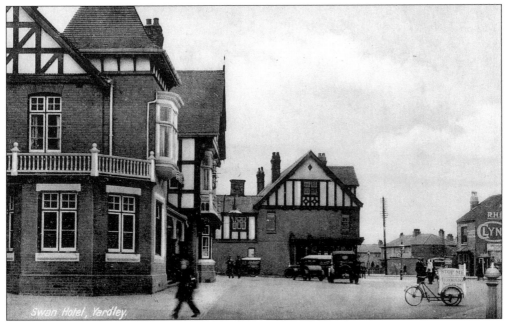

The side of the Swan and a view of Yardley Road, c. 1930.

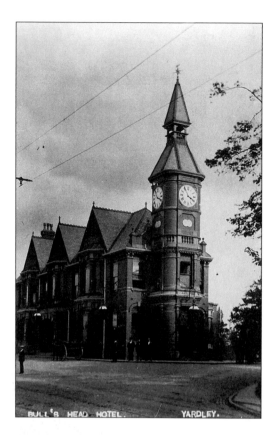

The Bulls Head, Coventry Road and Waterloo Road, c. 1910. This impressive building was another landmark, but was lost in 1984.

The Hay Mills Picture House being demolished, 1927. It had opened in 1913. The new Adelphi cinema was built alongside and opened the same year.

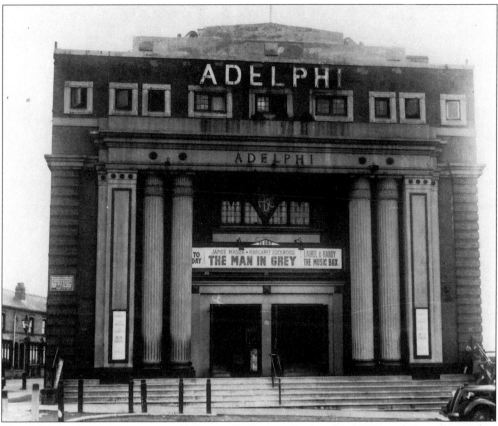

The Adelphi, 1947. This cinema had over 1200 seats. It closed in 1968 and since then it has been the Coral Reef nightclub, a builders' merchant, and a Gurdwara and community centre.

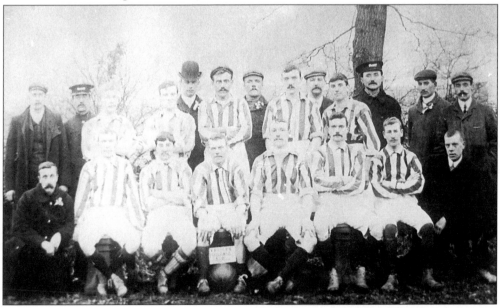

Yardley Football Club, c. 1919. The man in the bowler hat is one of the Painters.

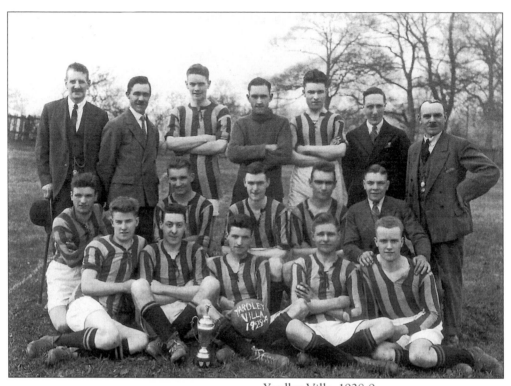

Yardley Villa, 1928-9.

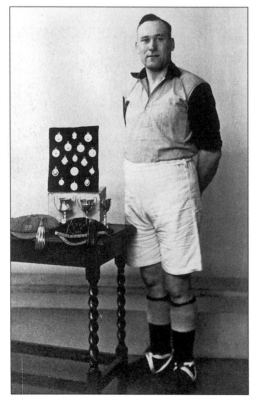

Frank Sparrow. He was a very talented centre-forward who played for South Birmingham Boys, Birmingham Boys, England Boys, and Walsall F.C. He was killed in action in March 1945. See also page 115.

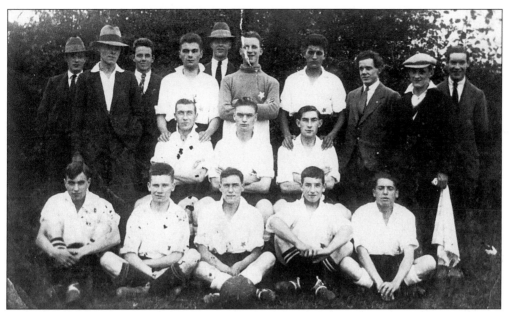

Church Road Old Boys Football Team, 1930's.

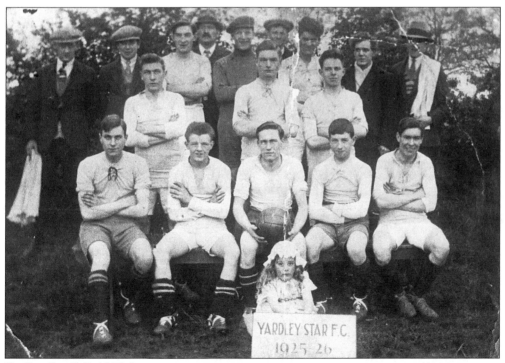

Yardley Star F.C. 1925-6.

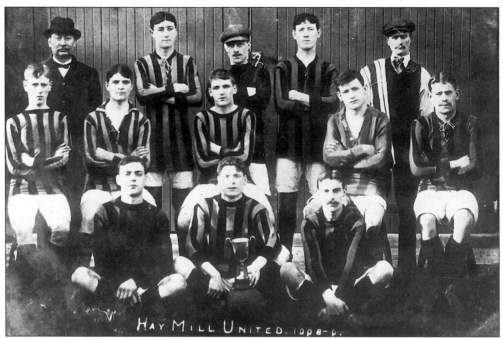

Hay Mill United A.F.C., 1908-9.

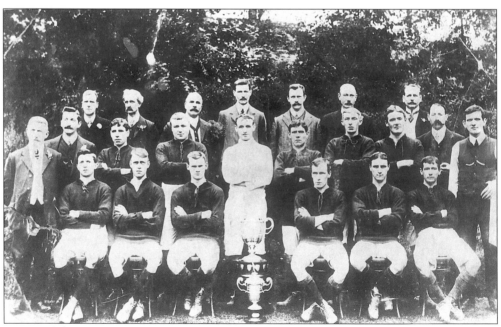

Latch and Batchelor's Football Team, 1918.

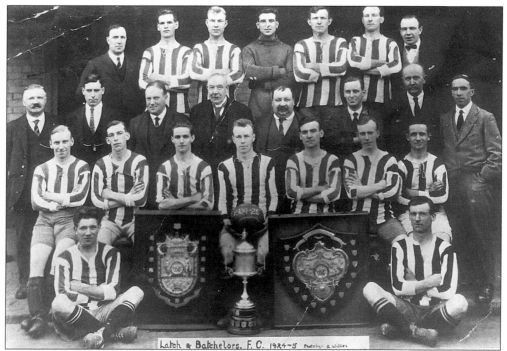

Latch and Batchelor's Football Team, 1924-5.

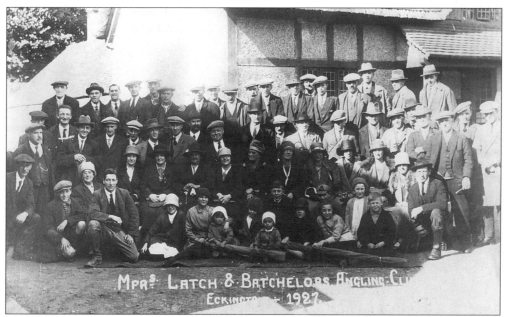

Latch and Batchelor's Angling Club, 1927.

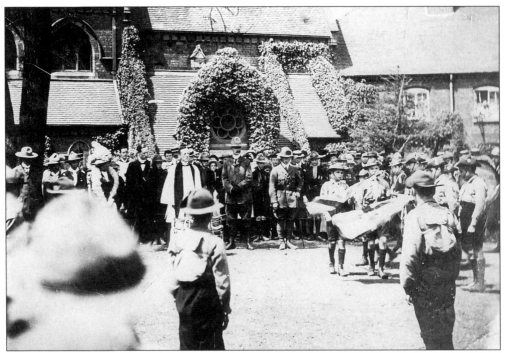

St. Cyprian's Church Boy Scouts on parade, 1920's.

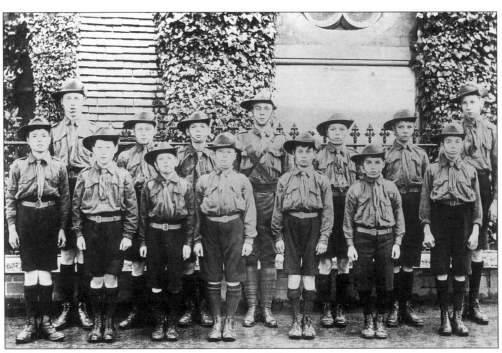

St. Cyprian's Boy Scouts standing to attention, 1920's.

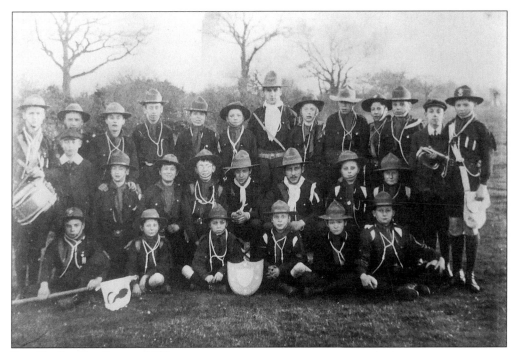

First Yardley Boy Scouts, 1920.

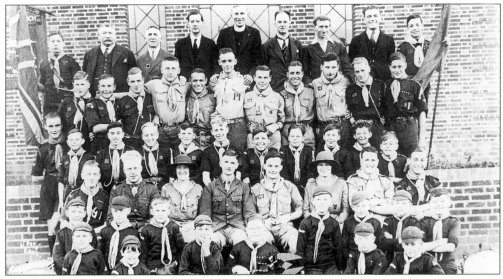

South Yardley Methodist Church Boy Scouts and Cubs, 1931.

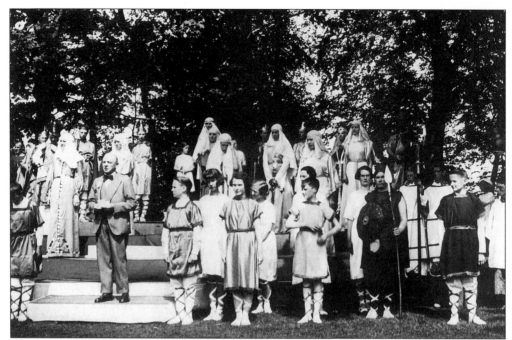

Mr. E.W. Salt, M.P. for Yardley, opening the Yardley Pageant, June 1936. This was written by Canon Cochrane on the theme of the Royal House of Alfred the Great and was performed in the vicarage gardens in aid of the Bishop of Birmingham's Church Extension Fund.

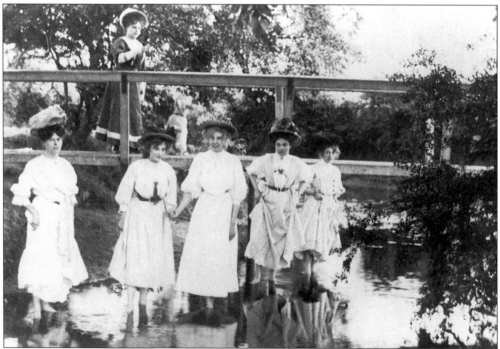

Ladies at the Hobmoor ford bridge, c. 1900.

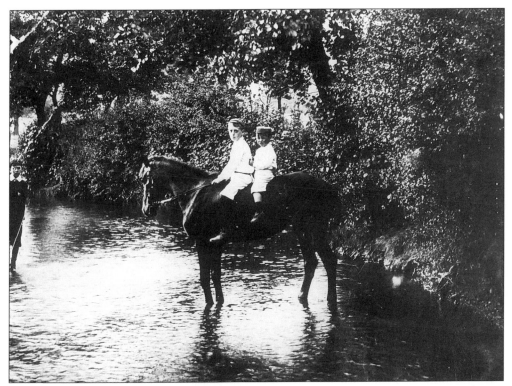

The Deakin brothers on horseback in the Cole, 1907.

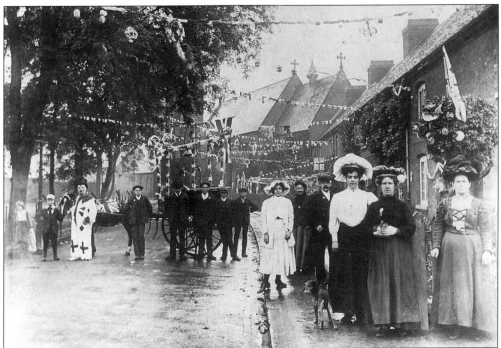

Celebrations in the Fordrough, perhaps for the Coronation of Edward VII, 1902. Despite the outfits and decorations, there are not many smiles here!

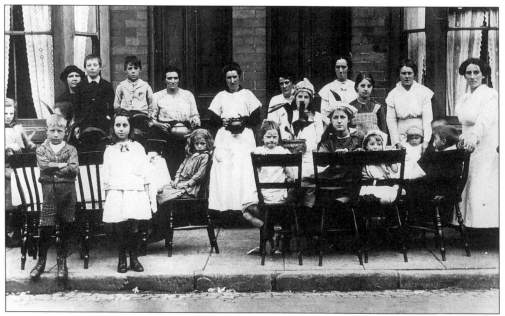

Kings Road Victory Party, 1918. Once again, no one seems very happy.

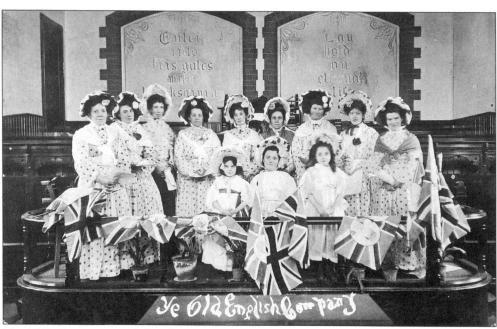

Hay Mills Congregational church group, c. 1910.

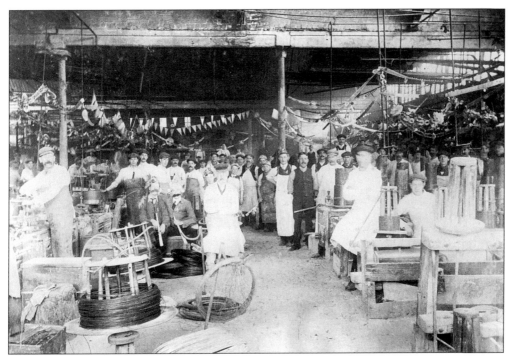

Wire works celebrations at the end of war, 1918.

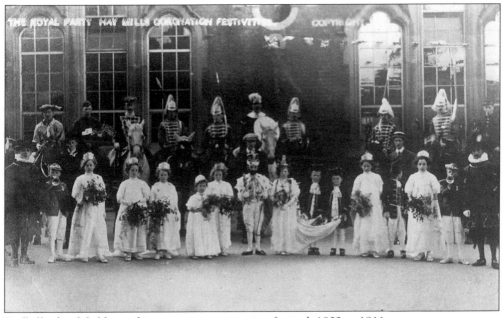

Redhill schoolchildren taking part in a coronation festival, 1902 or 1911.

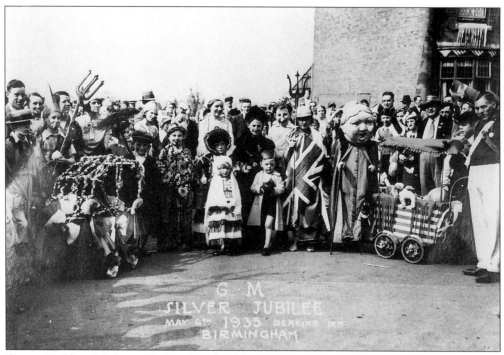

George V Silver Jubilee at Deakins Road, 6 May 1935.

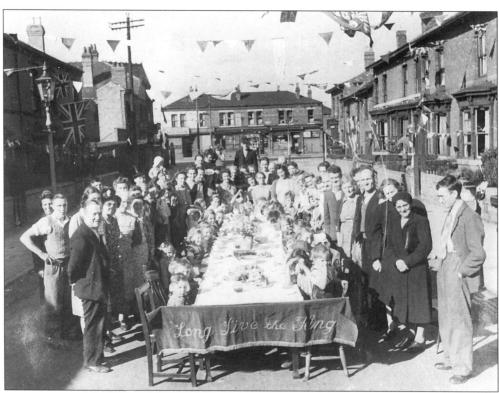

Coronation party for George VI, George Road, 1937.

Six
Schools

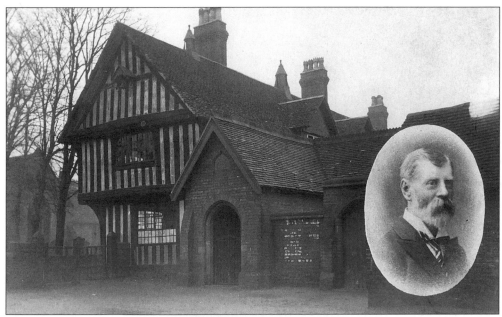

A commemorative postcard of the Trust School with its last Master, Revd William Sutherns, c. 1908.

Ex-pupils outside the Trust School, c. 1923.

Boys from Redhill School, c. 1905.

Redhill School girls giving a delightful performance, c. 1910.

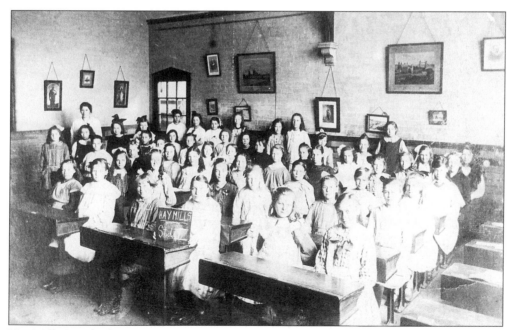

Hay Mills Standard V.

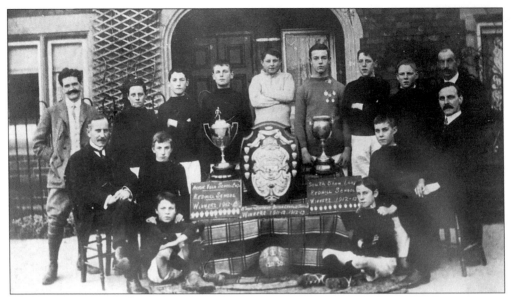

Redhill School Football Team, 1912-13.

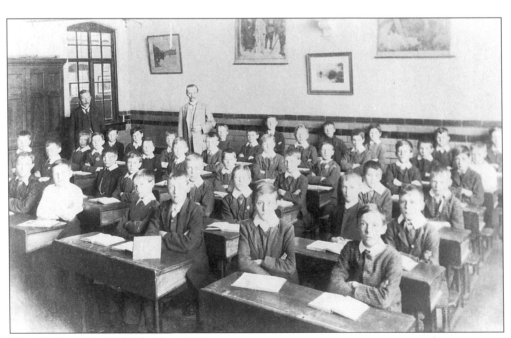

Class IV boys, Redhill School, c. 1915.

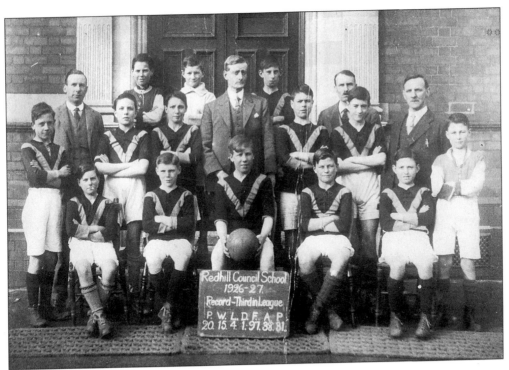

Redhill School Football Team, 1926-7.

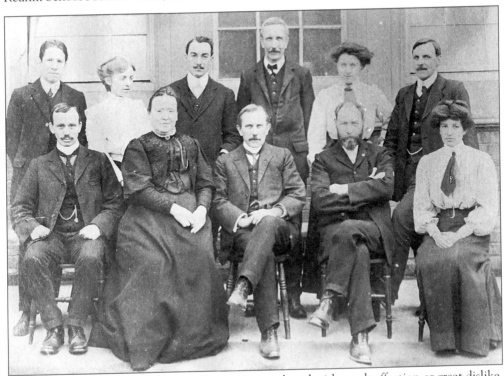

Teachers from Redhill School. Miss Penney, remembered with much affection or great dislike, but definitely remembered, is second from the left on the back row.

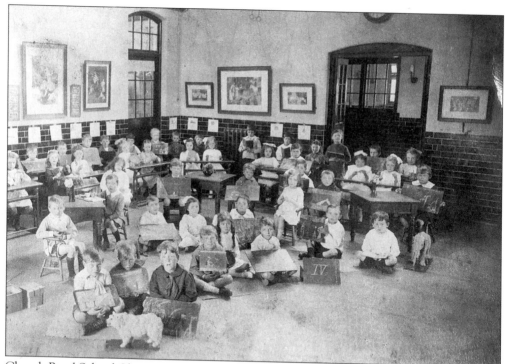

Church Road School Class IV mixed infants, c. 1910.

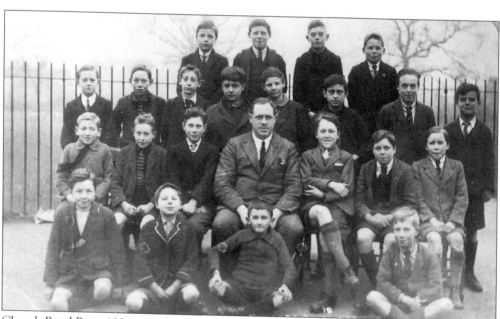

Church Road Boys, 1924.

114

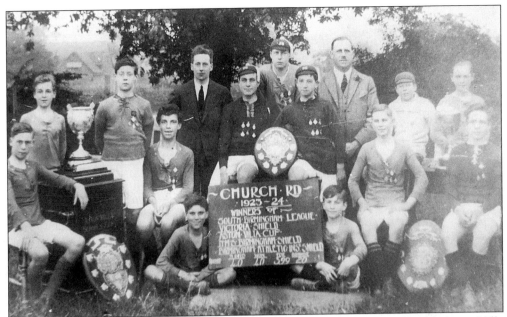

Church Road 1923-4, winners of the South Birmingham League, Victoria Shield, Aston Villa Cup, M.M.S. Birmingham Shield, Birmingham Athletic Institute Shield.

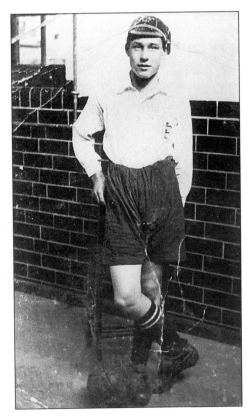

The wins above were no doubt considerably aided by Frank Sparrow, seen here as a boy footballer. See also page 98.

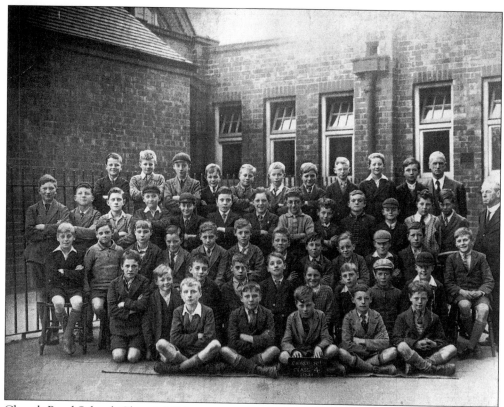

Church Road School, Class 4, 1931.

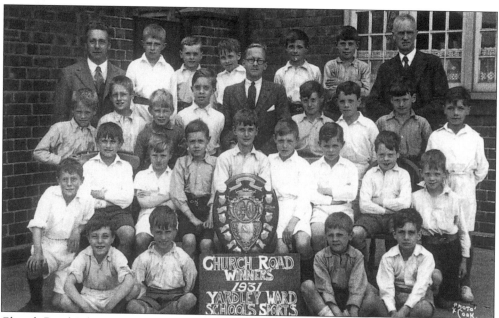

Church Road School, winners, Yardley Ward School Sports, 1931.

Seven
Portraits

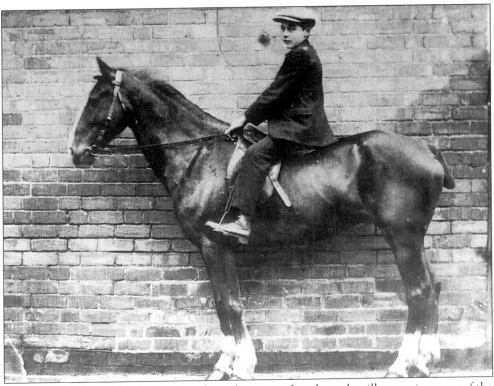

This section contains family photographs and portraits. Local people will recognise many of the individuals. This is (Gilbert) Joseph Pinfold, c. 1922.

Herbert Pinfold, *c.* 1917, known as 'Sunny'. He died as a young man.

An earlier photograph of Jo Pinfold, c. 1912. He died in September 1991.

Ernest Pinfold, 1878-1953 outside his butcher's shop, 1012 Coventry Road.

George Muscott and Dr. Tim Tailby, M.R.C.S., c. 1920. George Muscott died in 1933, aged 98. Clearly, tannery fumes did not shorten his life!

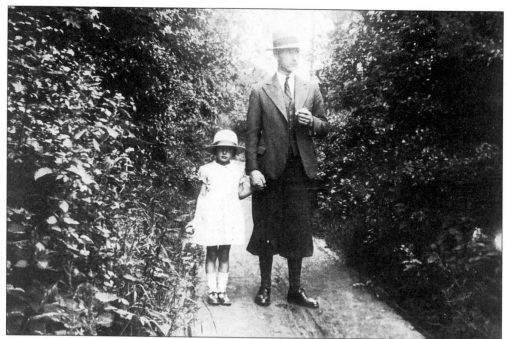

Alfred Compton with his daughter Valerie, six years old, at Moat Lane, 1931. He worked at Snow Hill, and later as stationmaster at Olton and at Acocks Green, where he won prizes for the best kept station.

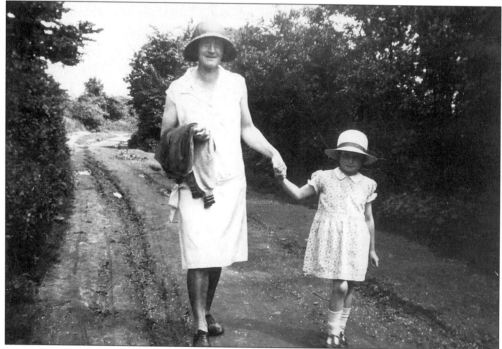

Lilian Compton and Valerie at Moat Lane, 1931. Around this time, mother and daughter were walking along Garretts Green Lane when they received shotgun pellet wounds to the legs. Someone shooting pheasants was too close to the lane.

Annie Taylor, c. 1935. Annie Taylor lived next to the old Gwyther cottages on the Causeway off Church Road, near 'Derrington's' chapel. The chapel and the first cottages have now gone. She has made a recording of her memories for the City Museum.

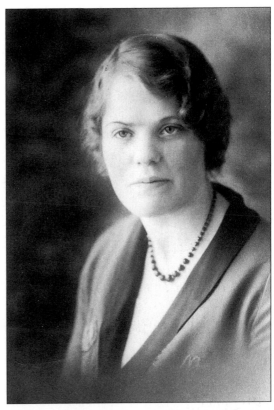

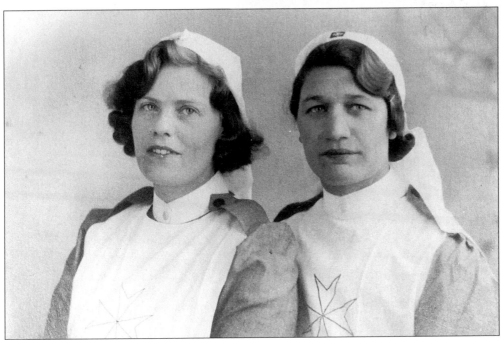

Annie Taylor and Mrs. Marjorie Spittle on night duty at Wilmot Breeden, wearing Civil Nursing Reserve uniform, c. 1940.

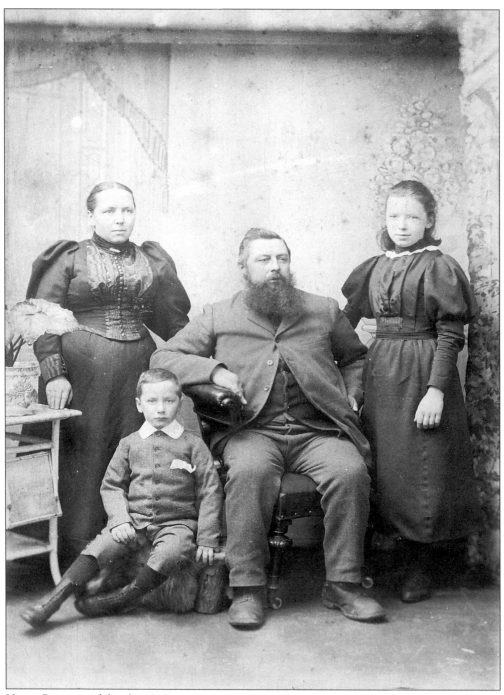

Henry Painter and family, 1897.

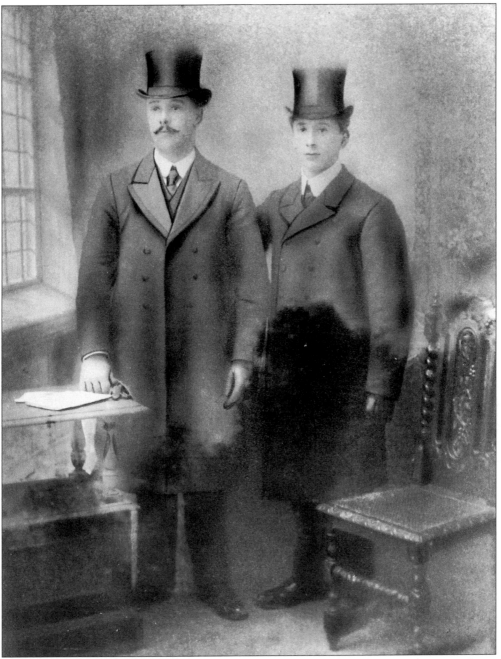

William and Frederick Painter portrayed in a magazine, c. 1910. A different impression of men was certainly given in those days.

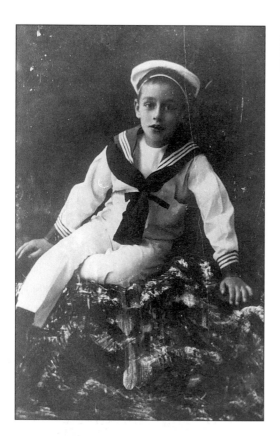

Arthur Painter followed his father into the business. He died in 1966, aged 67. Here he is as a young child in a sailor suit, c. 1904.

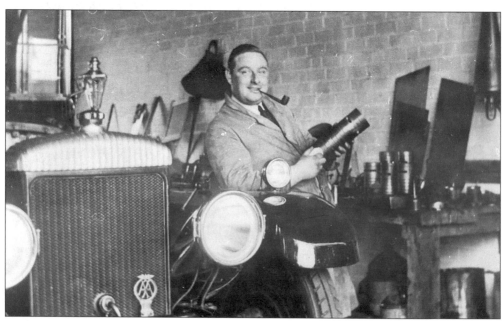

William H. Painter in the repair shop, 1930's.

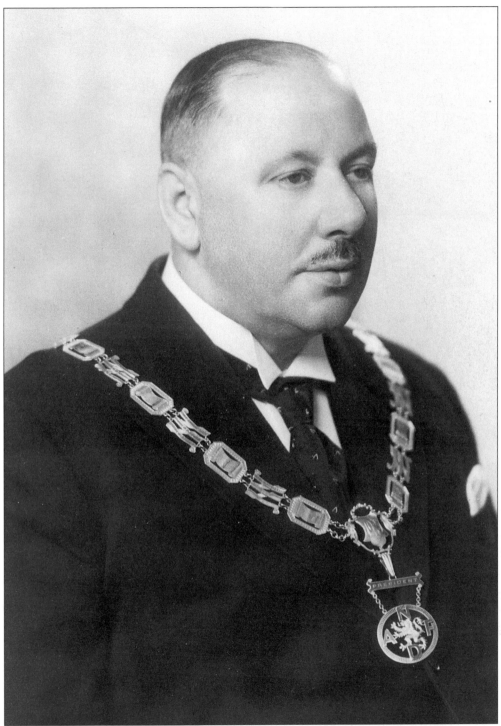

William H. Painter as President of the National Association of Funeral Directors. He was also a City Councillor, an Alderman, and a Freeman of the City of London.

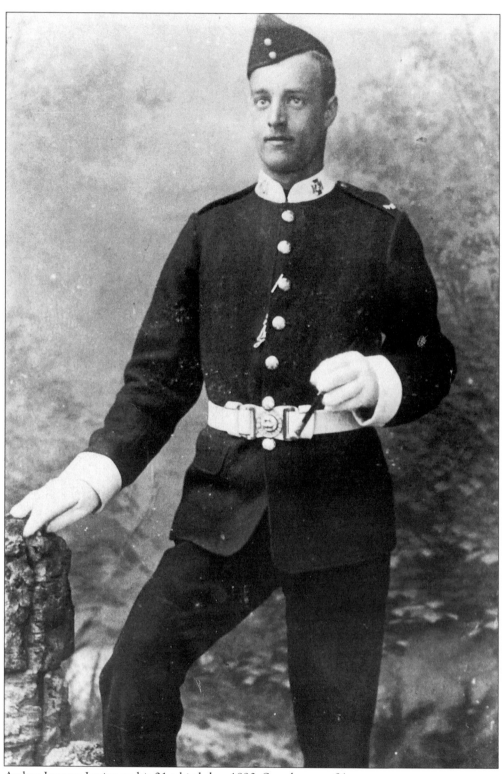

Arthur Jacques Junior on his 21st birthday, 1890. See also page 91.

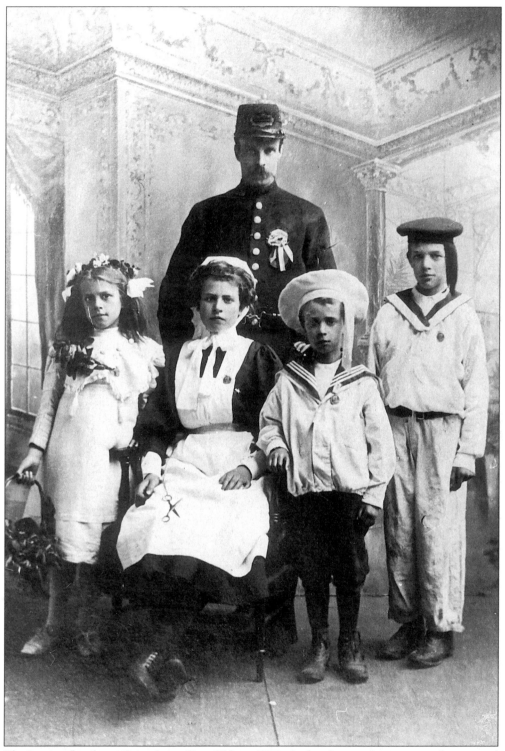

The Jacques family on Coronation Day, 22 June 1911. Arthur Jacques Junior is standing; seated left to right are: Eva, Ada, Walter and Arthur the third.

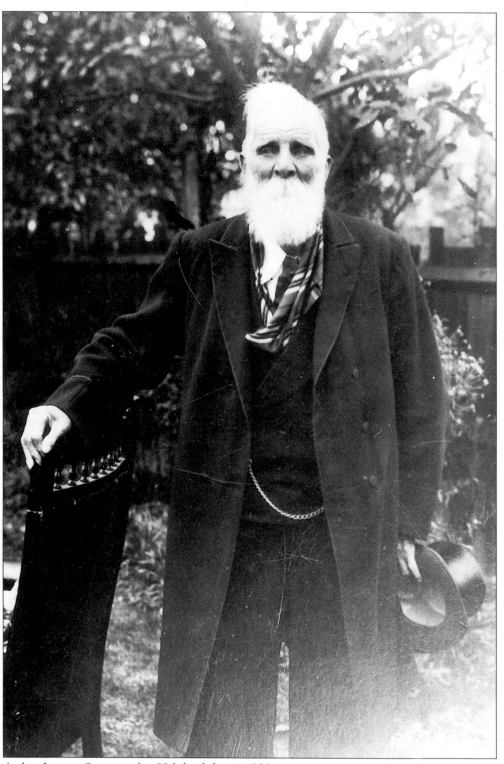

Arthur Jacques Senior on his 90th birthday in 1933.